IMAGES
of America

PIERRE PART

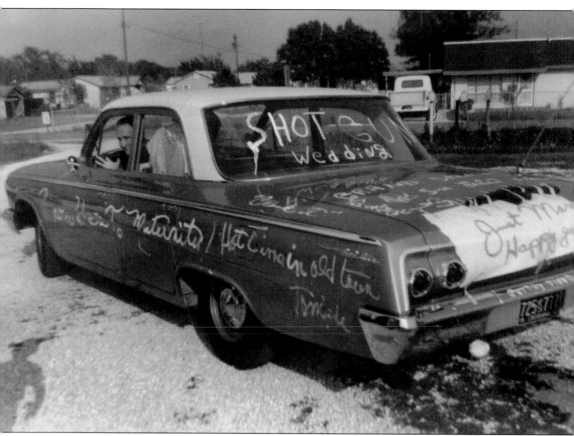

Aubrey Landry and Rose Gaudet Landry were married on Mother's Day, May 13, 1962. Aubrey's godfather, Eno Theriot, hid Aubrey's vehicle and decorated it with shoe polish and beer cans. The car is pictured as the newlyweds saw it when they came out of the church. They went to Florida for their honeymoon. (Courtesy of Effie Landry.)

On the Cover: It was a beautiful day for a wedding at St. Joseph Catholic Church on June 27, 1959, when Brent Cox Jr. and Georgiana Cavalier Cox were married. Crowds of people entered the church to witness Father LaPierre marry Brent and Georgiana. The church was built in 1942, facing the bayou. In the early 1960s, it was replaced by the current church, founded by Fr. John T. Martin. (Courtesy of Georgiana Cavalier Cox.)

IMAGES
of America

PIERRE PART

Geneve Daigle Cavalier
and Tre' Michael Caballero

ARCADIA
PUBLISHING

Published by Arcadia Publishing
Charleston, South Carolina

Printed in the United States of America

Library of Congress Control Number: 2014955112

For all general information, please contact Arcadia Publishing:
Telephone 843-853-2070
Fax 843-853-0044
E-mail sales@arcadiapublishing.com
For customer service and orders:
Toll-Free 1-888-313-2665

Visit us on the Internet at www.arcadiapublishing.com

CONTENTS

ACKNOWLEDGMENTS

I would like to express my deepest thanks to all the people who have helped me put the pieces of our history together. Your photographs and stories truly inspired me to continue to put together *Pierre Part*. Thanks to Tre' Michael Caballero, my oldest grandson, for the "English" side of the book and my newfound friend Vivian Achee Solar for inspiring me and encouraging me when the tides were rough. Thanks to my family for always standing by my side as I worked many hours putting this book together. I would like to thank my grandmothers for passing down all the stories and tales they shared with me as I grew up. My goal was to visit as many people as possible in the search of photographs and stories of our past. This book was written in hopes of inspiring the younger generation to learn about the past and how their ancestors lived. Our ancestors lived simpler lives, and they were very poor. Some would say that they were rich at heart. Although the times were tough, family and friends were always close and able to help out when needed. As I see it today, those were the "good ol' days." Thinking back to my childhood, I remembered saying that if I had children I would give them more than what I had if I could. Well, as time went by, things changed, and like everyone else, I gave my children what they wanted and more. Today is different, and most people focus on wants instead of needs. So to the younger generation, the children of Pierre Part, and my grandchildren, I hope that this book will help you understand some of what earlier generations went through to build what we have today.

INTRODUCTION

Our little town of Pierre Part, with its long roots in the past, lies on the edge of Assumption Parish. Nearly surrounded by water, Pierre Part is virtually an island. The only way our ancestors were able to travel was through the use of waterways. Many people settled on the banks of the bayou, which gave hardworking families access to what seemed to be a goldmine. Living off the available land was no easy task, with so much water surrounding it. However, what land they could use was employed in every way possible. Even though a steady supply of fish was always available and as easy to catch as simply putting a pole or line out in the water, some seafood, such as crabs and crawfish, was seasonal. Families truly lived off the land and sea. People relied on different sources of income throughout the year. Usually when crabs and crawfish were out of season, families would earn a living trapping, picking moss, logging, and catching other types of fish.

Later in history, as the agricultural age came upon us, Pierre Part began building and operating plantations. These produced various products, but sugar cane was the main cash crop due to its value and demand. Trading also became popular, and a simple bartering system was established among the settlers. Often goods such as seafood, moss, livestock, and cattle were traded for food, plants, and herbs. When times were bad, people would put their house and land up for food.

Our ancestors, who primarily spoke French, were forced to learn English in school. Students were punished for speaking French. Today, French is taught in the schools, but it is "the king's French," or proper French that is taught. Our language is Cajun French, deemed the backwards way of speaking French.

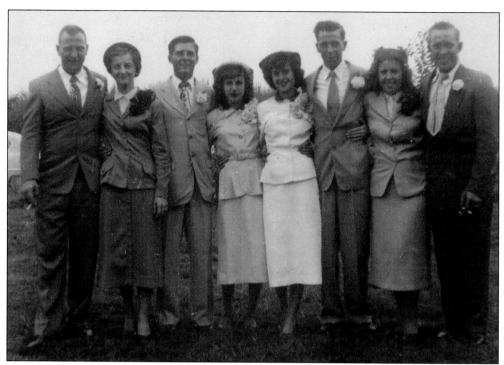

Johnny Acosta and Margret Blanchard Acosta were married on August 26, 1953. Johnny and Margret are pictured here with their wedding party. From left to right are Haywood Blanchard, Effie Landry, Harold Crochet, Dora Blanchard Hebert, Margret and Johnny, Geraldine Acosta Landry, and Nicole Landry. (Courtesy of Effie Landry.)

The wedding of Ameline Landry Daigle and Carol Daigle was held at the family house. Pictured here from left to right are (first row) Gervais "Dude" Landry (under the table), Audrey Landry Michel, Norris Landry, and Diane Landry Lakey; (second row) Elidia Hebert Landry, Noeline Landry LeBlanc, Ameline (bride), Carol (groom), Roy LeBlanc Sr., and Noelie Landry LeBlanc. On the porch is Duffy Landry. (Courtesy of Duffy and Myrtle Matherne Landry.)

One

CHURCHES

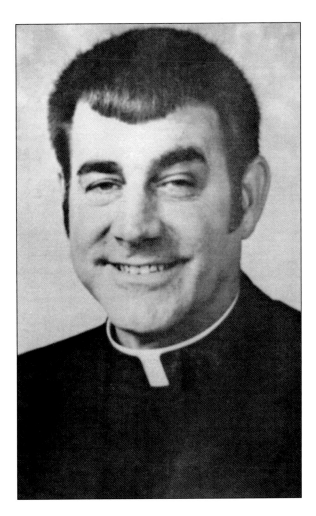

Fr. Thomas Joseph Allain was ordained June 7, 1947, at the age of 26. Father Allain came to St. Joseph Church in October 1975 and died soon after on December 21. He was very well known and liked during the short while he spent as a priest at St. Joseph. (Courtesy of Levie Gaudet Theriot.)

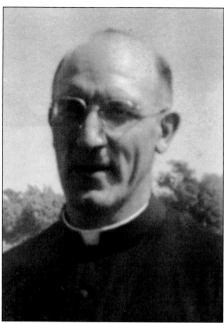

Fr. Romeo LaPierre was ordained on May 20, 1940, and came to Pierre Part in the early 1940s. Father LaPierre was the priest at St. Joseph Church for many years. He was born April 10, 1911, and died March 21, 1967. (Courtesy of Levie Gaudet Theriot.)

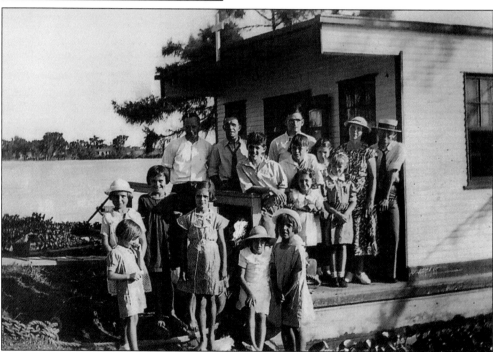

In the early 1900s, Mary, Star of the Sea Floating Chapel traveled to Four Mile Bayou, Belle River, and Bayou Pigeon. The priest would take the chapel boat and go to places where people had no church. Here, it is parked at the bayou side of Honora Breaux and Ursule Daigle Breaux house not far from the Belle River Bridge. Emelda Ackman Blanchard is sitting on the boat with her white dress and hat; the girls on the left of her are Lizzie Daigle Landry, Lassie Mae Pipsair Gros, May Metrejean Landry, and Annie Metrejean Mabile, and the father is up above them with a white shirt. (Courtesy of Emelda Blanchard.)

St. Joseph's small chapel was built in 1850, but high water in 1882 destroyed it. All the statues fell in the water and deteriorated except the Blessed Virgin Mother, which landed on its feet and was not destroyed. In 1892, when Father Pillain visited Pierre Part and heard about the incident, he suggested putting the statue where it could be seen. It was placed on the island across from the chapel. In 1898, a Canadian priest started to build another church, and in 1909, a storm destroyed the statue and knocked the church down on what was left of the chapel. The statue was replaced, and the church rebuilt. In late 1910, it became active. In March 1940, a tornado destroyed the church, and another was built in 1942. Pictured here is the Blessed Virgin Mother on the island. (Courtesy of Moise and Ann Landry Breaux family.)

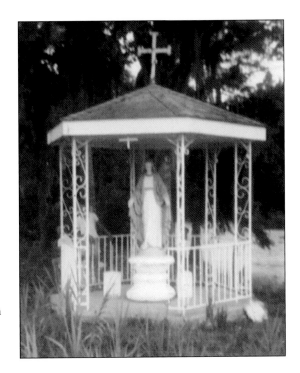

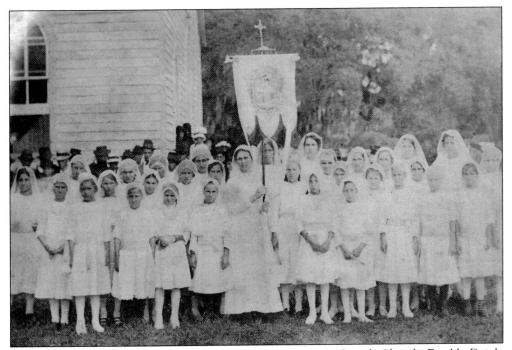

These children have just made their First Communion at St. Joseph Church. Emelda Daigle Ackman, daughter of Tremond and Aurila Daigle, is sixth from the left in the first row of this photograph, taken in 1911. (Courtesy of Emelda Ackman Blanchard.)

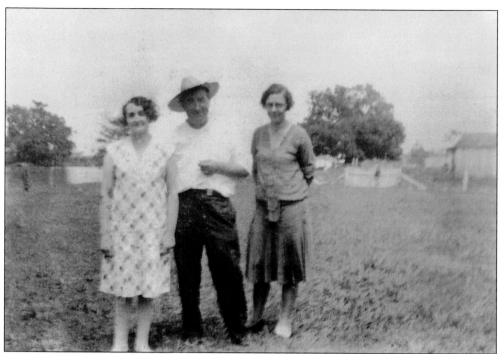

Father Dusal is pictured here in 1920 with Mausella Ellen, one of his assistants, on the left. He was buried by the big cross in the Pierre Part Cemetery. (Courtesy of Levie Gaudet Theriot.)

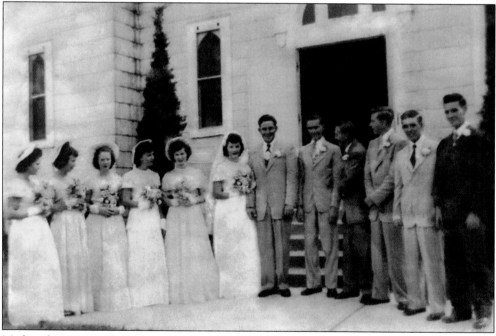

Medward "Wine" and Carrie Daigle Ponville's wedding day was August 26, 1950. Pictured here from left to right are unidentified, Shirley Cavalier Domingue, Winnie Simoneaux Daigle, Lou Mae Daigle Pipsair, Nancy Metrejean, Carrie, Wine, Floyd Daigle, Jimmy Cavalier, unidentified, Dudley Domingue, and Eric Alleman. (Courtesy of Shoni Ponville Hebert.)

Fr. John T. Martin served St. Joseph Church as priest for many years, and headed the construction of the current church building. The groundbreaking was held on November 3, 1962, and the structure was completed August 28, 1964. Built by Charles Carter and Company of Baton Rouge, Louisiana, the church holds 700 worshippers. (Courtesy of Karen Gaudet St. Germain.)

In 1964, St. Joseph Catholic Church was built. The rectory is visible next to the church, and it appears that mass has just finished and people are walking to their cars. Many changes to the church, rectory, and parking lot have been made since this photograph was taken in June 1984. (Courtesy of Georgiana Cavalier Cox.)

Effie Landry is pictured here in 1962 sitting on a dirt road in Belle River; behind her is the Bell River Baptist Church. Effie's sister Celine Landry Vaughn was getting married, and they were at Beaugard and Laura Richard Vaughn's house. (Courtesy of Effie Landry.)

Rev. Lawrence Thibodaux of First Baptist Church in Thibodaux became friends with Sulia Gaudet, who was baptized by an evangelist named Cross who traveled up and down the river. In 1941, Brother Ira Marks and Reverend Lawrence held a revival meeting at the Little Brown Church on the Water. In 1953, the first members were Ernest Breaux and his daughter JoAnn. Grace Breaux, Noeline Landry LeBlanc, and Lillian Cavalier Gros Leonard soon followed. Ernest was a gracious man. On April 2, 1967, Noeline, Rev. John Johnson, James LaBauve, and Brother Ernest broke ground, and the church was dedicated in June the following year. An education building was constructed in 1978, and Darren Carpenter has been the pastor for years. (Courtesy of Belle River Baptist Church.)

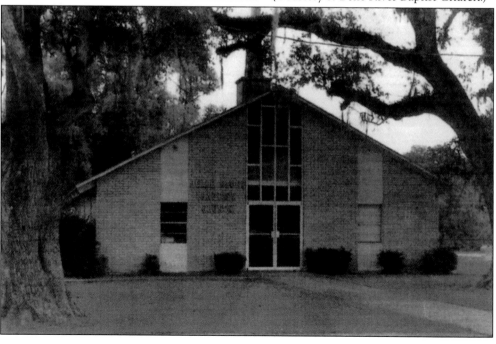

Sacred Heart Chapel in Belle River held this First Communion ceremony in the late 1950s. From left to right are (first row) Morris Blanchard, Mildred Pitsair Guillot, Kathy Leonard, Claudett Perera Shields, and Pat Miller; (second row) Grady Gaspard, Connie Mayon, Penny Miller Gauthier, Julie Digle, and Linda Aucoin Templet. (Courtesy of the Chester Gaspard family.)

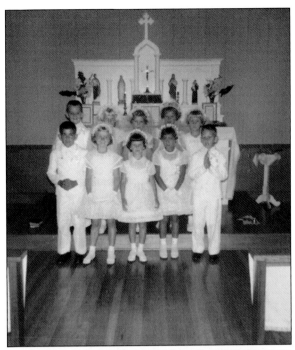

On Sunday morning, Sacred Heart Catholic Church in Belle River would sell religious articles. Pictured here in March 1959 are Claude "Sho Sho" Cavalier (far left) and Lucille Blanchard Gaudet in the white coat. Many religious items such as mass books, medals, rings, necklaces, and crosses were sold. (Courtesy of Georgiana Cavalier Cox.)

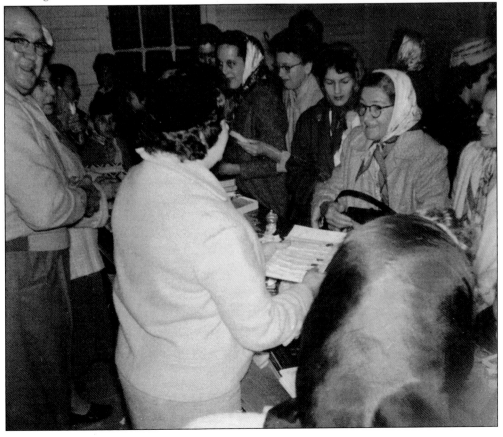

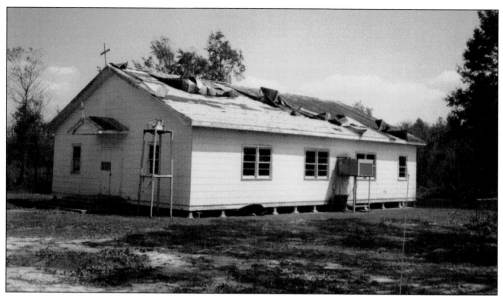

Sacred Heart Chapel was destroyed by Hurricane Andrew in August 1992. Mass was held at 7:00 a.m. on Sunday mornings, and many residents and campers crowded the little one-room chapel. The chapel is missed by many people today. (Courtesy of Georgiana Cavalier Cox.)

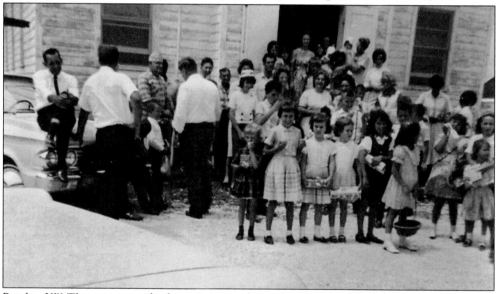

Brother J.W. Thompson was the first minister to bring the Church of God message to Belle River. In late summer 1922, Brother Thompson held revivals at Lake Verret, about three miles from Belle River. At times, 25 people from Belle River would attend. Walking through a wooded area, they would carry lanterns to light their way. Many of the members from Belle River were baptized in the river. On July 5, 1925, the Belle River church was organized with 43 members under Pastor R.W. May. The church was small at that time, so when a crowd came they had services under the big oak trees by the edge of the river. Through the years, the church has had many good, faithful leaders and undergone numerous improvements. This photograph of Church of God of Prophecy was taken after Sunday services. Doug Watson has been pastor for the last 15 years. (Courtesy of Church of God of Prophecy.)

Leland "B" Gaudet (left) and his brother Gildy were churchgoing people. They took this photograph at a church in Morgan City. Neither B nor Gildy ever married. They worked with their father, Sulia Gaudet, at his store growing up. They were both members of Church of God of Prophecy. (Courtesy of Grace Vaughn Dupre.)

Pictured here are Ozelia "Grand Maw FeFe" Ackman Lambert (facing the camera) and Thirsteen Gaudet Michel (facing right). Grand Maw FeFe and Thirsteen were at a church convention, and they are members of the Church of God of Prophecy. (Courtesy of Grace Vaughn Dupre.)

Pastor Edward Bledsoe was a pastor of Household of Faith in Gonzales. He had a dream to start a nondenominational church in the Pierre Part area, and in the 1990s, purchased property on Highway 70. In 1991, Gerald Daigle began holding home meetings, which grew to become a church group. Pastor Bledsoe donated a double-wide trailer to be put on his property for the church, and it became Pierre Part Christian Church. One year later, Pastor Gerald felt it was time for a permanent place and began construction of the first building, making Pastor Bledsoe's dreams a reality. Pastor Gerald began to build another building in 2002, which took two years to complete. The first church building is now being used for fellowship meetings. Pictured here is the church and its sign. (Both, courtesy of Pierre Part Christian Church.)

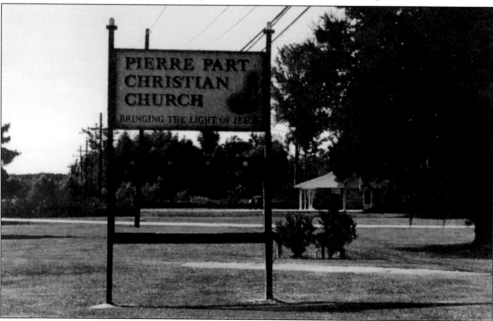

Founded in 1992, the former Way Fellowship Church evolved into New Covenant Community Church under the care and leadership of Joseph "Joe" Sedotal, known as Brother Joe. The Way Fellowship Church started with 10 members, and New Covenant Community Church currently has 120 members. Brother Joe has always been the pastor. Pictured above is the first one-room church on South Bay Road. The new church on Highway 70 is pictured below. (Both, courtesy of Joe and Cheryl Campo Sedotal and New Covenant Community Church.)

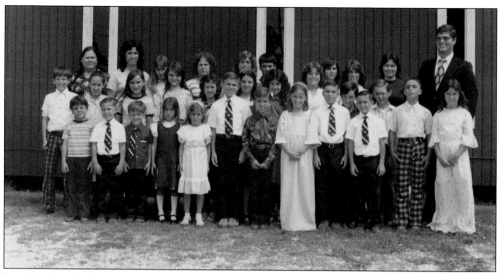

In 1974, Otis Roland from Florida started Bayou Tabernacle, which met on Lee Drive. The first converts were Herbert Landry and Horace Hebert. The church moved briefly to North Bay Road, and Pastor Mike Hare named it Berean Baptist Church. Landry sold the land on Bayou Drive to the church for $1, and building began in 1975. A Christian school under Pastor Mike Hare operated until 1985, and Pastor Danny Jackson changed the name to Victory Baptist Church. Several men served as pastor during the church's 40 year history. The current pastor is Jerry Rockwell, since 2002. Pictured here from left to right are (first row) Shelia, Mary, Melissa, Rachael, Verna, Gary, Melissa, Melissa, and Roberta; (second row) Nottsie, Harrison, Marilyn, Melinda, Martha, Janine, Elizabeth, Dennis, and Lyle; (third row) Trampas, Nathan, Jacob, Sonja, Christy, Harlan, Solomon, Sheila, Layton, Jason, Bronson, and Sarah. (Courtesy of Victory Baptist Church.)

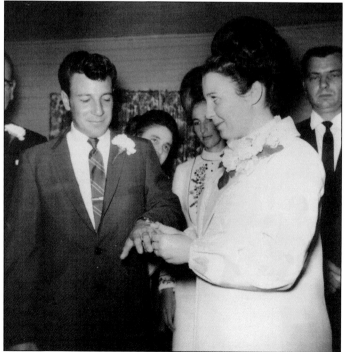

Leonard "BB" Lacosta and Audrey Domingue Lacosta's wedding day was February 19, 1972. BB and Audrey were married at the home of BB's parents. The man and woman behind Audrey are Clarence Ponville and Gene Acosta Ponville. The woman peeking out from behind BB is Debra Domingue Gaspard. (Courtesy of Georgiana Cavalier Cox.)

Two

SCHOOL DAYS

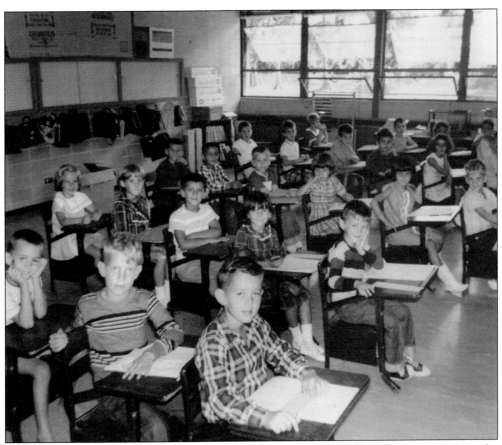

Mary Ann Knotts was the teacher was of this classroom at Pierre Part School in 1967. In the second desk of the second row is Mary Hebert Cavalier, and behind her is Andrew Hebert. The students look like first or second graders, and this was before they even had air conditioning. (Courtesy of Georgiana Cavalier Cox.)

In 1925, five-year-old Chester Gaspard is playing in the front yard of the schoolhouse in Belle River. The schoolhouse was located where Chester Gaspard's house currently is today, on Belle River Road. The teacher was Ivy Mae Boudreaux. (Courtesy of the Chester Gaspard family.)

Ivy Mae Boudreaux taught school in Belle River. Boudreaux loved her children, and they loved her too. Grace Vaughn Dupre was one of 10 students, and Boudreaux sent Grace this photograph of herself on June 23, 1934. (Courtesy of Grace Vaughn Dupre.)

The house on the right is the old schoolhouse that was "Down Da Bay" (South Bay Road). It was located where the Sevin House is today. One of the teachers was Genevieve D. Fournerette, who likely taught in the late 1930s. (Courtesy of Audrey St. Germain Guillot.)

Pierre Part School students (from left to right) Laura Louise Woodrufe Simoneaux, Relma Gaudet Dugas, and Geneva Breaux Gros pose outside in the early 1950s. (Courtesy of Geneva Breaux Gros.)

Every year in May, the Pierre Part School held a maypole dance; pictured here is the dance in 1940. The girls were taught to dance around the pole with streamers in their hands. Lou Ann Landry is among these girls, but her position is unknown. (Courtesy of Therese Landry Theriot.)

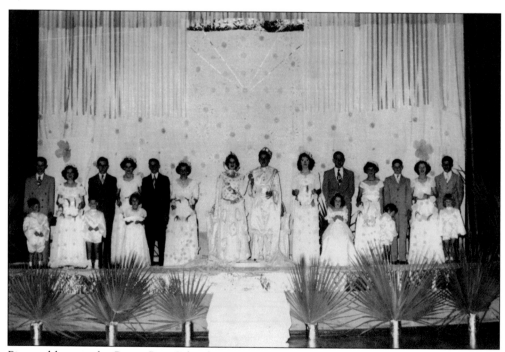

Pictured here is the Pierre Part School gymnasium in the 1950s. May crowning was a special occasion, and the court consisted of the queen, king, and 12 runner ups. They also had six smaller children as attendants. (Courtesy of Effie Landry.)

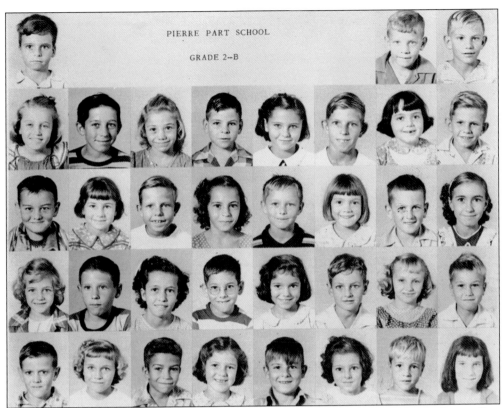

Pictured here are Pierre Part School second grade students in 1950. From left to right are (first row) Lucien Alleman, B.J. Torres, and Harry Hue; (second row) Delta Aucoin, Bill Leonard, Rite Mae Richard, Ronald Sedotal, Eve Vining, Jesse Landry, Kay Knotts, and Urtis Mabile; (third row) Horace Gaspard, Telizia G. Landry, Gilbert Landry, Molly Breaux, Adam Landry, Beatrice Blanchard, unidentified, and Maggie Metrejean; (fourth row) Shirley Theriot, Gerald Domingue, unidentified, Andrew Blanchard, unidentified, Carol Crochet, Aggie Olivier, and Jesse Guillot; (fifth row) Willie Landry, unidentified, Donald Perera, Lena Mae Mabile, Herbert Breaux, unidentified, Ned Blanchard, and Mary Jean Leonard Boudreaux. (Courtesy of Donald Perera.)

During recess at Pierre Part School in March 1967, the children are standing in the yard on the side of the bus ramp. It is believed that the boy with the striped shirt is Barry Breaux. (Courtesy of Georgiana Cavalier Cox.)

25

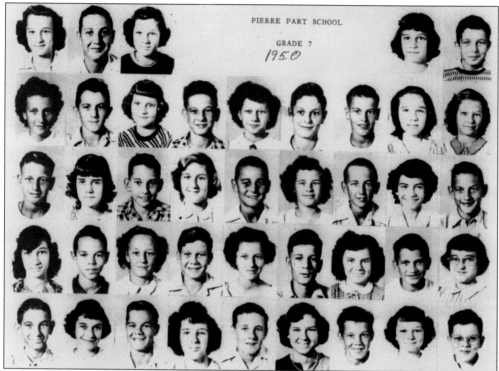

In 1950, Pierre Part School seventh grade students pose for a photograph. Pictured here from left to right are (first row) Angelle R. Blanchard, Haywood Blanchard, Maude C. Landry, Anna Lee C. Melancon, and Jeffery Breaux (second row) Virgis C. Cavalier, Henry Breaux, Mary Jane Tourere, Ernest Theriot, Maudry Anne G. Hebert, Gerald Fryou, Leonard Aucoin, Ella Mae R. Landry, and Mary Ann S. Coupel; (third row) Hubert Aucoin, Margret B. Acosta, Ronald Comeaux, Jane B. Miller, Willie Landry, Eve Anne M. Alborado, U.J. Landry, Deanne Perera Aucoin, and Lugi Hue; (fourth row) Lillie May T. Simoneaux, Floyd Eskine, Mable A. Ourso, Jessie Mabile, Mary Jane L. Dugas, Jimmy Alleman, Anne A. Landry, Calvin Landry Sr., and Geneva V. Michel; (fifth row) Leonard Verret, Doris Bernucheaux, Orean Giroir, Rose Mary Blanchard, Leonard Theriot, Anna C. Hebert, Rivers Templet, Wilma B. Simoneaux, and Risely Mabile. (Courtesy of Lillian Mabile Chedotal.)

It appears as if these students at Pierre Part School are about to put on a play or sing. This photograph is from the early 1940s, judging by the appearance of the gymnasium. From left to right are Gladys LeBlanc Charlet, Harold Crochet, two unidentified, Hazel Cavalier, Herbert Cavalier, Jeanne Mabile, and unidentifed.

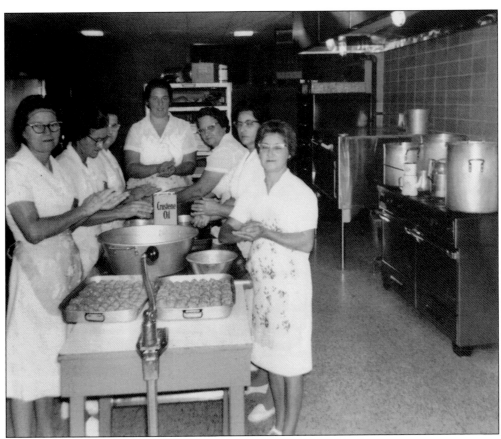

Pictured here are the cooks at Pierre Part School in the 1960s, rolling meatballs for spaghetti. From left to right are Amelia Coupel, Regina Templet, Marie Rivere Landry, Betty Richard Blanchard, Amelie Berthelot Perera, Elma Landry Daigle, and Elvy "Shorty" Rivere Hebert. These women worked together a long time. (Courtesy of Georgiana Cavalier Cox.)

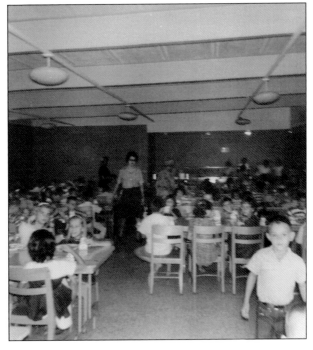

The Pierre Part School cafeteria is bustling at mealtime in the late 1960s. The cafeteria serves breakfast and lunch for the students from kindergarten through eighth grade; pictured here is the smaller children's meal period. (Courtesy of Georgiana Cavalier Cox.)

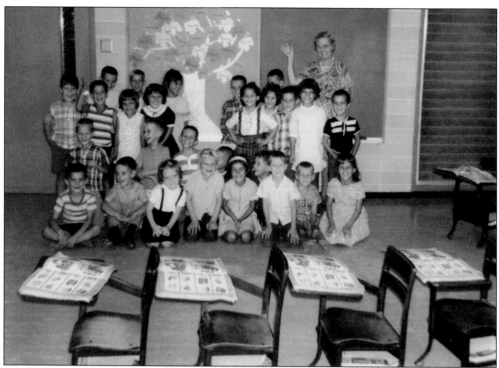

Mary Ann Knotts Templet graduated from college in 1963. In 1964, she started teaching first grade at Pierre Part School, but when she had her first child in 1973, she took time off. She returned to teaching in 1984 and retired in 1999 after 27 years. Pictured here are Templet and her first grade students. (Courtesy of Georgiana Cavalier Cox.)

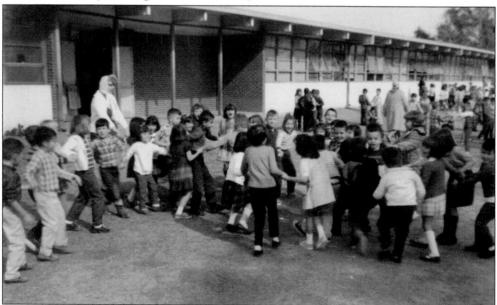

In 1967, Mary Ann Knotts Templet and her first grade students at Pierre Part School play outside during recess. It must be a cool or windy day, because Templet has a scarf over her head. (Courtesy of Georgiana Cavalier Cox.)

Three

INDUSTRY

This photograph was taken inside a Pierre Part business in June 1968. (Courtesy of Moise and Ann Landry Breaux.)

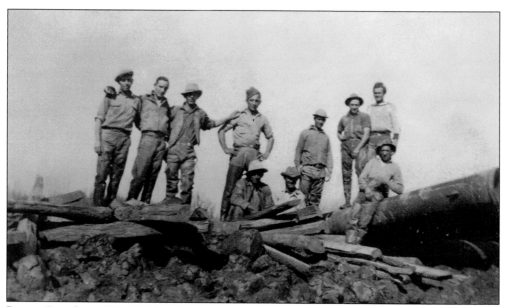

Bernie Grandin and his brother were loggers, and they used axes or *passe-partout* (two-handled saws) to cut down trees. Pictured here is the logging crew they worked with; Bernie and his brother are sitting in the center. (Courtesy of Ruby Metrejean and Beulah Grandin.)

Lester Dashin was a foreman of this group building a levee in Bayou Long. Pictured from left to right are (first row) unidentified, Raymond LeBlanc, and Leonie "Lo Lo" Theriot; (second row) Chester Pipsair, Lester Dashin, and Claude "Sho Sho" Cavalier. Pipsair lost his thumb on this job in 1949; he was 17 years old at the time. (Courtesy of Georgiana Cavalier Cox.)

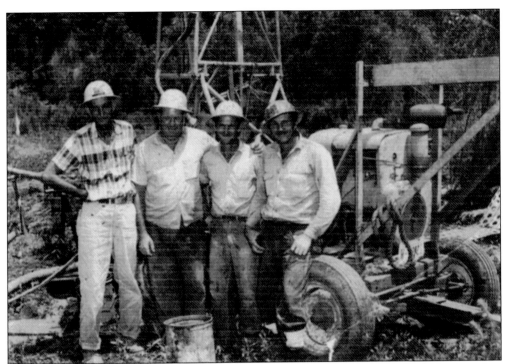

Jahncke Services had a crew of men who would drill in different places to check the dirt; they employed many in the area during the 1940s. This job was in the Atchafalaya Spillway. Pictured from left to right are Captain "Gros" Sanchez, Joe Moss, Uyless Landry, and Albert Hebert. Hebert was 22 years old at the time. (Courtesy of Shirley Hebert Blanchard.)

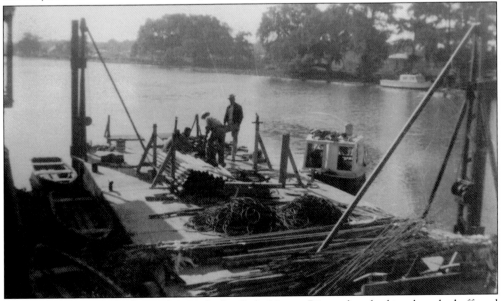

Pictured here is a dredge barge that worked in Lake Verret. Rig workers had just knocked off, and were tying the barge to the back of the Pierre Part Store. Bright and early in the morning, the workers would come and bring it back to the lake and work all day. In the late afternoon, they would return it to the Pierre Part Store for the night. (Courtesy of Effie Landry.)

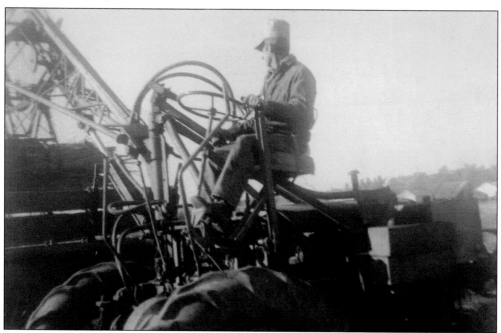

Ines Landry worked for Leland Theriot in the sugar cane fields. He drove the cane-loading machine and the cutting machine. He is pictured here cutting cane in 1961. (Courtesy of Effie Landry.)

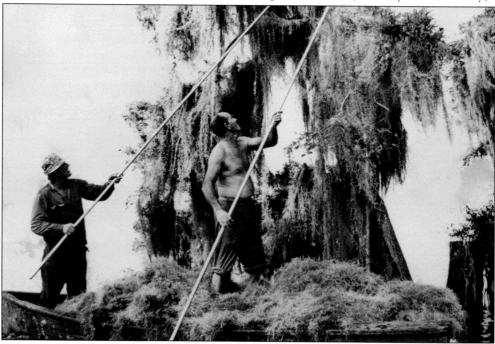

For many people in the Pierre Part area, moss picking was how they made a living. Albert Hebert (left) and his brother, Adolph "Ringo" Hebert, are pictured here picking moss in the 1960s. Ringo has picked moss all his life, and at 84 years old, he still can. Moss was used in many products, including walls, mattresses, pillows, sofas, and chairs. Today it is also used for crafts and plants. (Courtesy of Shirley Hebert Blanchard.)

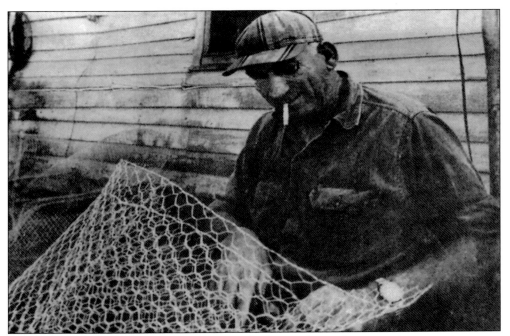

O'Neil Theriot is making crawfish traps out of galvanized wire. It was cut into two pieces, one for the barrow, and the other for the top, which was then shaped like a cone. He is sewing the cone on top the barrow. Crawfishing is still a popular industry and pastime. (Courtesy of Kirby and Emelda Domingue Gaudet Landry and *LePenseur*.)

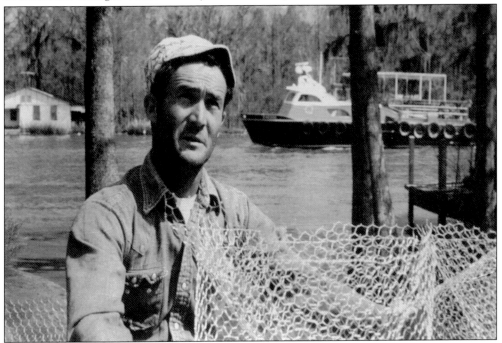

Iry Metrejean is getting ready for the crawfish season at the bayou side of his parents' house, Lloyd "T-Lloyd" and Noeline Grandin Metrejean. It is always nice to sit at the bayou and watch tugboats in the bay headed to Lake Verret. (Courtesy of Ruby Metrejean and Beulah Grandin.)

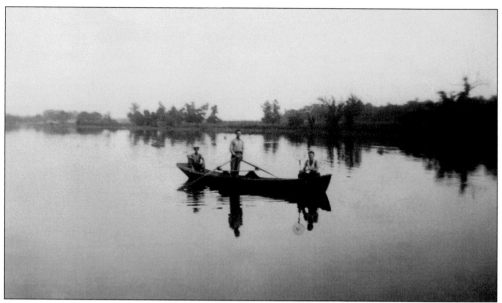

These three men seem to be raising a fish or crab line. It is a very serene image—a peaceful day from the simple life of long ago. (Courtesy of Winston and Audrey Landry Michel.)

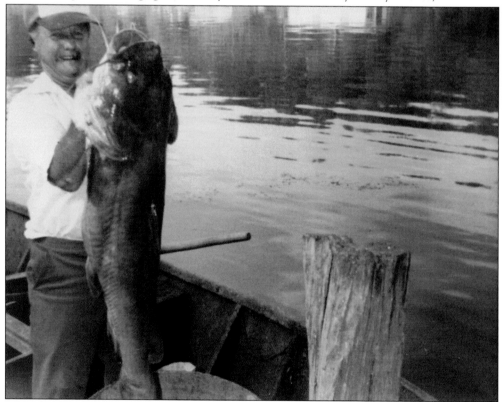

T-Lloyd Metrejean, when not at work, would put out his catfish lines. He is showing off the big catch of the day, as the fish was almost as tall as him. The photograph was taken in the early 1960s. (Courtesy of Ruby Metrejean and Beulah Grandin.)

Fishing was one of the ways Pierre Part residents could make a living. Joseph "Joe" Daigle was a commercial fisherman, and was a young man when he learned the trade of hoop-net fishing. He passed the trade down to his sons, Warren and Kevin "Crook" Daigle. In this photograph, Joe is holding the net, and Warren mans the front of the net. They fished frequently in the Atchafalaya Spillway. (Courtesy of Marion Gaudet Daigle.)

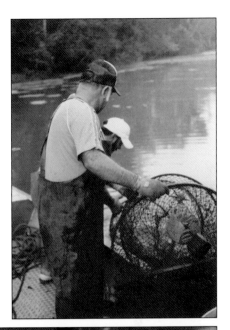

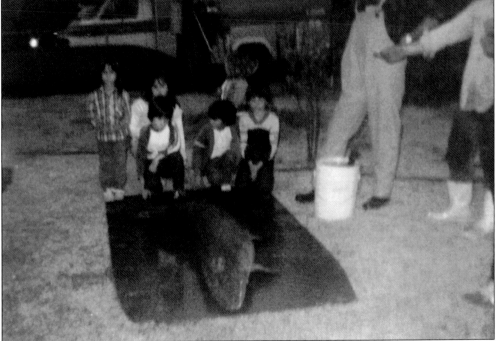

In the winter of 1982, Larry Cavalier and Darryl Leonard went to Lake Verret to place gill nets. The following morning they asked Darryl's brother, Terry, to ride with them to raise the net. As they approached the net, they could see something very large jumping and thrashing around. It was a 178-pound garfish. When cleaned and dressed, it yielded 99 pounds of meat. Pictured here with the garfish are, from left to right, Shannon Cavalier Boudreaux, Christy Leonard, Stafford Cavalier, Barrett Leonard, and unidentified; behind them is Dawn Leonard LeBlanc. To the right is Larry with his hand out and Darryl with the yellow slicker pants. (Courtesy of Rebecca "Becky" Daigle.)

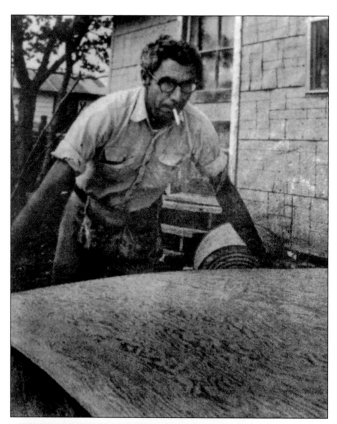

Pictured here in 1972 is Roy Hebert cutting out the bottom of a boat he was building. (Courtesy of Kirby and Emelda Domingue Gaudet Landry and *LePenseur*.)

Pirogues were used for work and play. Wilton Hebert Jr. learned the craft of building pirogues, and fashioned them out of cypress in different sizes and lengths. Hebert's works of art always sold quickly; pictured here in 1979 are just a few of his pirogues. (Courtesy of Vivian Morales Hebert.)

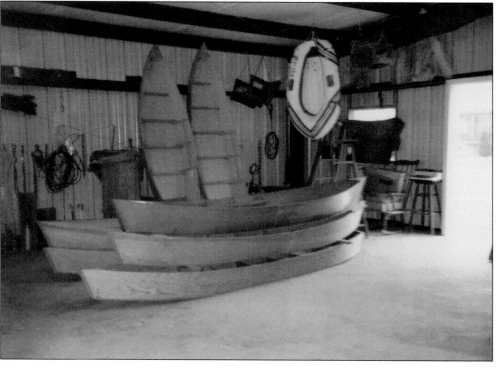

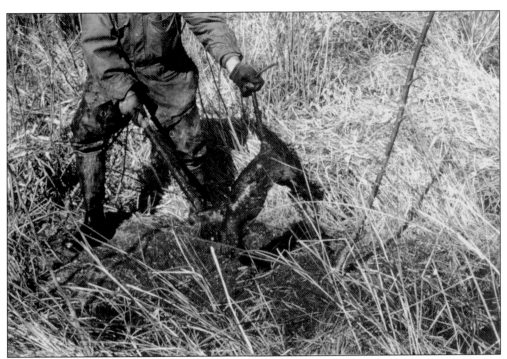

Joseph "Joe" Daigle checks his nutria traps and removes his catch of river rats. Trapping, cleaning, and stretching were a big part of life. Anything from raccoons, nutria, minks, beavers, and otters could be sold. Raccoon and nutria meat could be sold in a day. Today, nutria have a $5 bounty on just their tails. Joe still hunts and traps nutria at the age of 75. (Courtesy of Joe and Marion Gaudet Daigle.)

Jean Rivere Gaudet, age 53, holds her granddaughter Joann Gaudet Leal. Behind them are nutria furs stretched to dry. Jean cleaned and stretched many furs with her husband, Joseph Gaudet. This photograph was taken in the winter of 1966 in Bayou Penchant. (Courtesy of Joe and Marion Gaudet Daigle.)

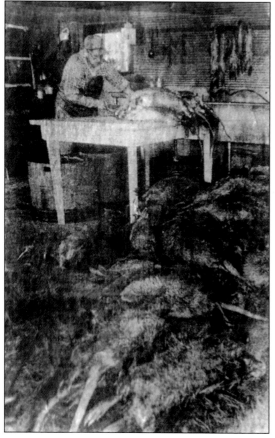

Marion Gaudet Daigle and her youngest son, Kevin "Crook" Daigle, are pictured here at their camp in Bayou Penchant. Marion was cleaning nutria that she and her husband, Joe, caught in their trap. They would often stay at their camp for weeks, and Crook was able to stay with them because he was not old enough for school. (Courtesy of Joe and Marion Gaudet Daigle.)

In 1969, Margie and her husband, Adley J. Richard, started a fur business, buying and selling nutrias, beavers, raccoons, minks and otters. Nutria and raccoon meat was also bought and sold. Adley died in 1992, and Margie kept the business running for one year before deciding it was too difficult to do alone. Margie is knee deep in nutrias in this photograph. (Courtesy of Ashley Richard.)

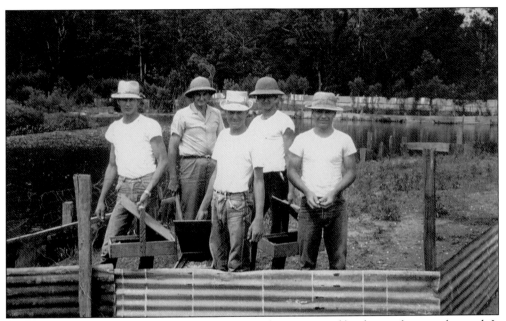

In 1952, at the age of 26, Edward J. Alleman bought 12 acres of land to make a turtle pond. It turned out to be successful. He would pick up to 5,000 eggs daily and ship the hatchlings to Europe and Japan. He is pictured here with his helpers in 1979; from left to right are Vincent Blanchard, Edward P. Alleman, Horace Mabile, Louis Blanchard Sr., and Adam Blanchard. Edward started working for his father at the age of 10. (Courtesy of the Edward P. Alleman family.)

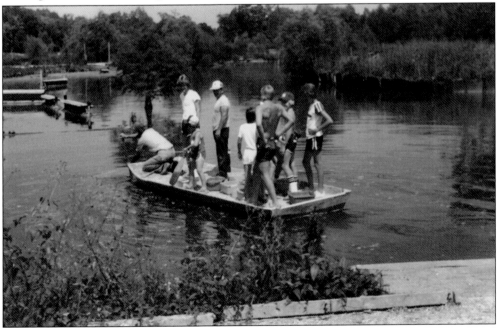

Edward P. built an island in the middle of his turtle pond for the turtles to lay eggs. He is pictured here in 1978 paddling to the foot of the island to harvest eggs. With him are Paul Alleman, Chad Alleman, Sidney Cavalier, Edward Alleman Jr., Kevin Theriot, and Trey Theriot. (Courtesy of the Edward P. Alleman family.)

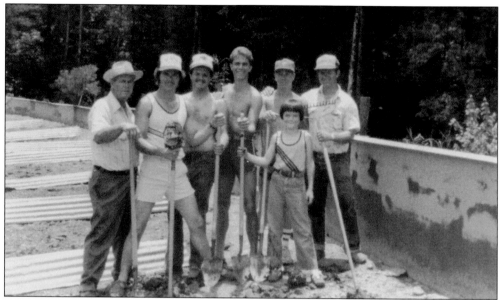

As a young boy of nine, Wilton Hebert Sr. started splitting logs, picking moss, trapping, running catfish lines, and crawfishing. As years passed and times grew hard, he went to work at Westfield Sugar Mill as an equipment operator. Wilton Sr. and Vivian Morales Hebert started their turtle farm in 1961. Wilton worked long hours catching bait to feed his turtles, harvesting eggs, and washing and hatching them. Together with their children they would pick 280 baskets with 70 eggs to a basket on a daily basis. In his biggest years, he sold 1.23 million baby turtles to Europe and Japan. Pictured working above are, from left to right, Wilton Sr., Robert Hebert, Michael Hebert, Paul Hebert, Greg Graham, and Wilton Jr. Hebert. Todd Breaux is in front. Digging for eggs below are, from left to right, Melissa Hebert Vidos, Christina Breaux Hudson, Vivian Morales Hebert, Lou Ann Hebert Breaux, Robert Hebert, and Wilton Sr. (Both, courtesy of Vivian Morales Hebert.)

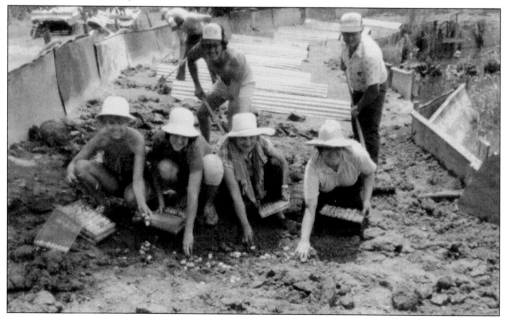

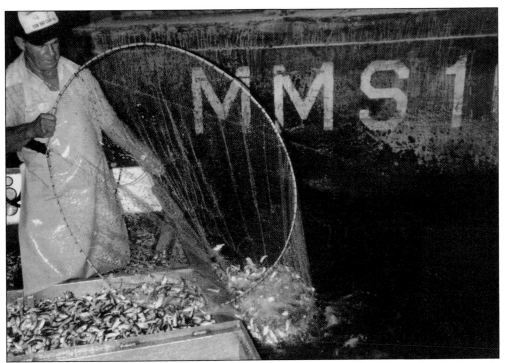

Wilton Hebert Sr. dips sardines next to an oil rig on Lake Verret to feed his turtles. In the early morning, right at daybreak, sardines lay their eggs. They were very plentiful, and Hebert could catch all he needed to feed his turtles. (Courtesy of Vivian Morales Hebert.)

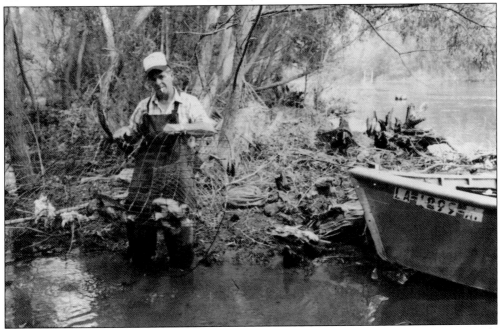

Wilton Hebert Sr. loved any kind of fishing. He is pictured here raising his snapping turtle traps. When in season, he would put his traps out to catch snapper. This was a good catch; two unsuspecting snappers wandered into his trap. (Courtesy of Vivian Morales Hebert.)

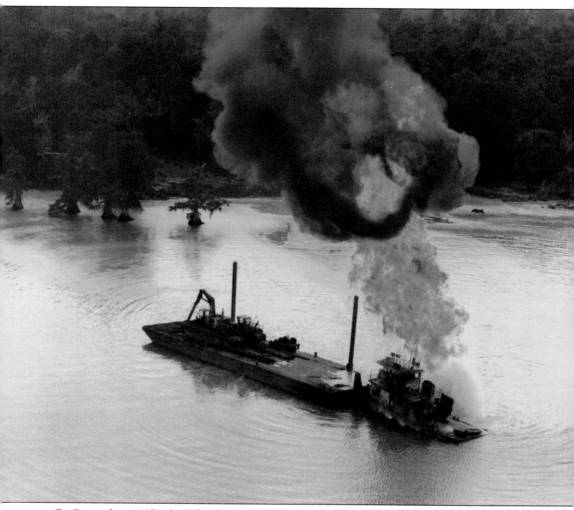

On September 4, 1979, the *Whiteface*, owned by Tidewater Marine Towing Company, was dispatched with a deck barge to pick up two men, a marsh buggy, and a backhoe from the west bank of Lake Verret. The towboat had just delivered it five days before. They hit something going in, but got clear. After loading the equipment on the barge, Capt. Phillip Hebert again hit something while slowly backing away from the bank. The marsh buggy's operator and oiler were on the barge, and they heard a thumping noise and saw mud, water, and gas spewing into the air on both sides of the tugboat and the captain running from the wheelhouse. Right before that, the two men had seen Daniel Dupre, the deckhand, entering the galley of the boat. The two men on the barge knew it could explode, so they got into a skiff and pushed off. Immediately, they heard an explosion and jumped into the lake. They swam to the aluminum boat, which had floated away from the burning tug, but it was too hot to touch. Both men suffered burns, and the crewmen's remains were found on the burned-out tugboat. The tug burned for hours. (Courtesy of Karen Gaudet St. Germain and Doreen Rivere.)

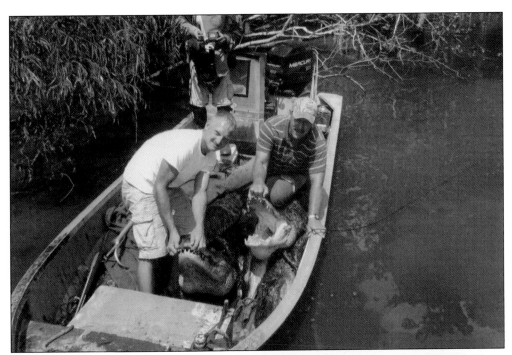

History Channel reality television stars "Choot-Em" Clint Landry (left) and Troy Landry are pictured in their boat showing off the catch of the day. The once-great pair no longer hunts together. (Courtesy of Clint Landry.)

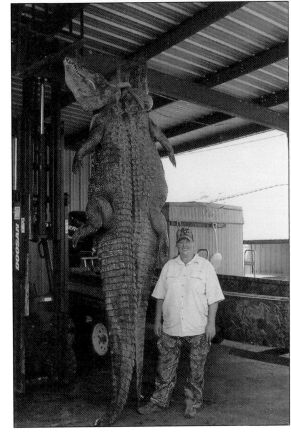

Marie Guillot Domingue Lacoste stands next to the two 12-foot alligators that she and Jacob Landry caught in 2012. Jacob is the son of alligator hunter Troy Landry. Marie enjoys alligator hunting and being outdoors. (Courtesy of Marie Guillot Domingue Lacoste.)

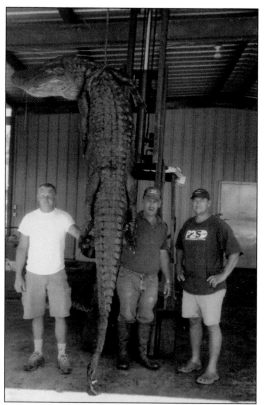

Troy Landry has just returned from checking his alligator lines. Pictured here are Clint Landry (left), Troy (center), and his brother Duffy "Bubba" Jr. Troy and Clint caught this big 12.5-foot alligator. They are at Duffy's Shell station, where the alligators are measured and put in a cooler. (Courtesy of Clint Landry.)

Troy Landry and his family hunt alligators, and Troy is passing down the tradition to his sons. Alligator season is in September. Pictured here from left to right are Guy Landry, Jacob Landry, Troy Landry, Chase Landry, and Brandon Hotard. Jacob, Chase, and Brandon are Troy's three sons. (Courtesy of the Troy Landry family.)

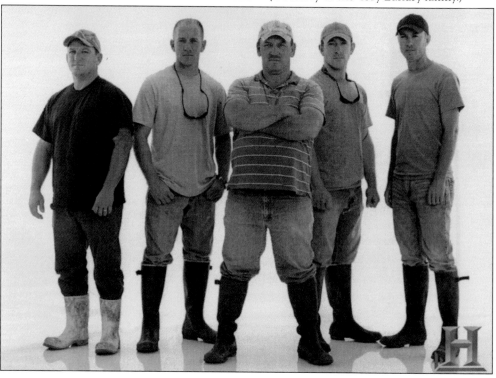

Gibson "Gip" Gaudet, a self-employed sawmill and crew boat owner, takes guests on a tour of the sawmill in the 1960s. Gip was continually showing people from all over the country what a cypress sawmill was and how it worked. Several newsmen, including Vernon Rogé, would bring people and film the way the sawmill worked. The sawmill was located behind Gaudet's house on South Bay Road. (Courtesy of Karen Gaudet St. Germain.)

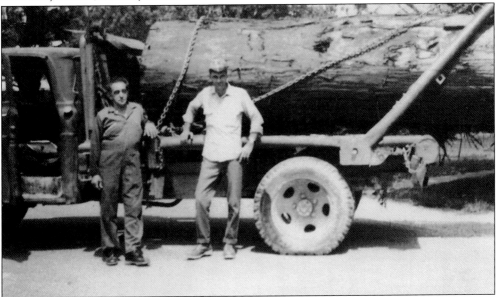

In 1965, Gip Gaudet (left) and his right-hand helper Jimmy Alleman (right) stand to take a photograph with a large cypress log they had just loaded on the truck. Jimmy was like one of the family at Gip and Alzie's house. (Courtesy of Karen Gaudet St. Germain.)

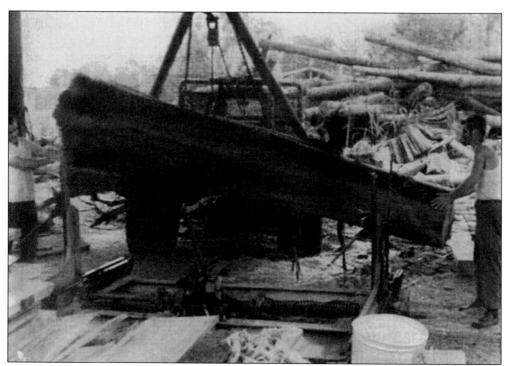

This photograph was taken at Gip Gaudet's sawmill. They were unloading a large cypress log that Gip and Jimmy picked up out on the water. It was a large job to cut and process this log, but it produced a large amount of lumber. (Courtesy of Karen Gaudet St. Germain.)

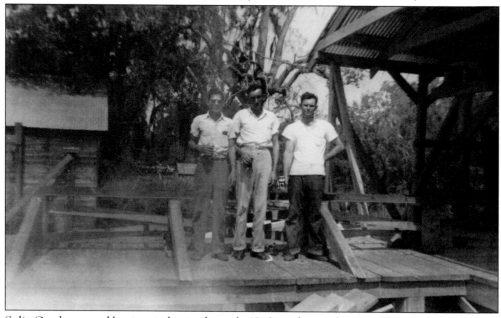

Sulia Gaudet started buying timber in the early 1940s and started a sawmill. It was located along Belle River, and they would haul the timber from the banks to the mill. The sawmill closed in 1964. Pictured here from left to right are Bernie Gros, Melvin Leonard, and an unidentified man. (Courtesy of Winston and Audrey Landry Michel.)

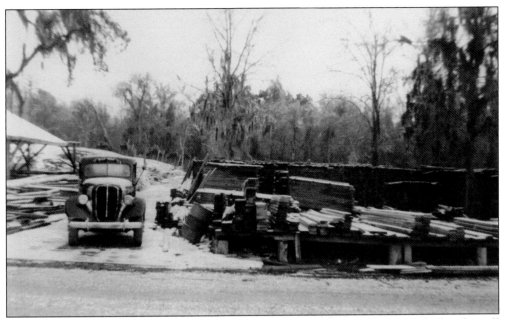

Sulia Gaudet has his lumber all stacked up in different sizes. Clarence Perera worked at the mill for many years as the grader, and would grade the lumber and stack it in the right place. (Courtesy of Winston and Audrey Landry Michel.)

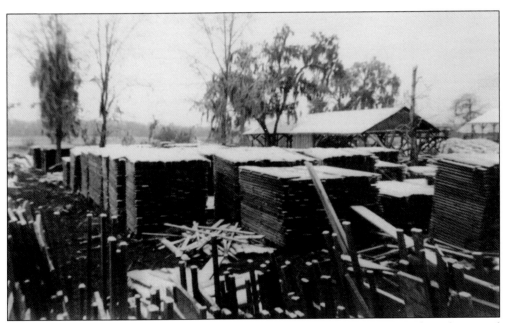

Sulia Gaudet had one of the finest lumber businesses around. His lumber yard was large, and people would come to him to buy lumber to build their houses. Sulia had many people charge their lumber, or trade him other goods like moss, fur, and fish. (Courtesy of Winston and Audrey Landry Michel.)

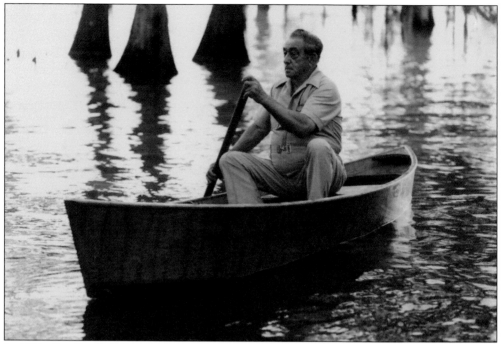

In 1981, Gip Gaudet takes a jaunt in his curly cypress pirogue, built by Raymond Sedotal. Gip put the pirogue in the water to try it out before it went to the Lafayette Museum, and this was the only time the pirogue went in the water. (Courtesy of Karen Gaudet St. Germain.)

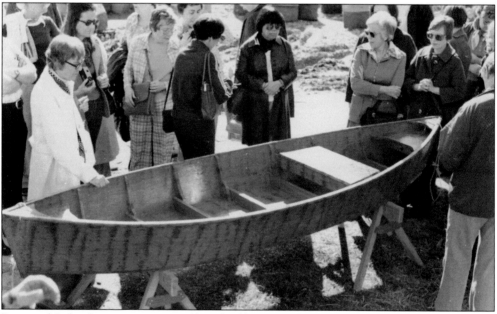

Raymond Sedotal was a carpenter and boat builder. He and Gip Gaudet brought this curly cypress pirogue to the Festival International de Louisiane, an annual music and arts festival held in Lafayette, Louisiana. The curly cypress pirogue was one of the attractions at the festival. People from all over would gather around the pirogue and listen to Sedotal and Gaudet speak about how rare the curly cypress was. (Courtesy of Karen Gaudet St. Germain.)

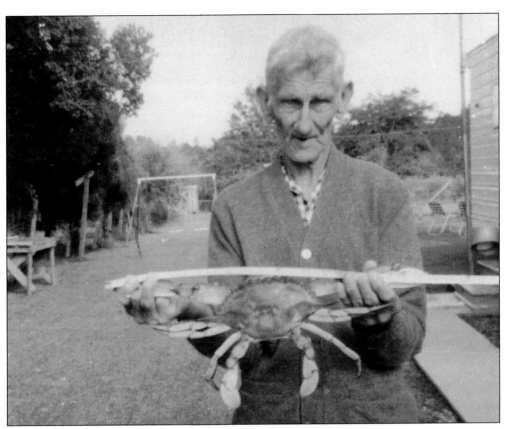

Clonie Mayon is measuring a big crab that he caught in the Belle River. He lived next to Gaspard Grocery for many years and crabbed right in front of his house. In 1953, Mayon worked for the Morgan City Elementary School as a janitor. (Courtesy of the Chester Gaspard family.)

Horace Gaspard loved playing with the wagon his grandfather Elton Gaspard gave him in the early 1950s. Elton would bring a crew of men in the back of his truck to work at May Brothers Lumber Company in Franklin, Louisiana. They would stay for the week and sleep in the back of the truck. When in season, he also used the truck to haul crawfish. (Courtesy of the Chester Gaspard family.)

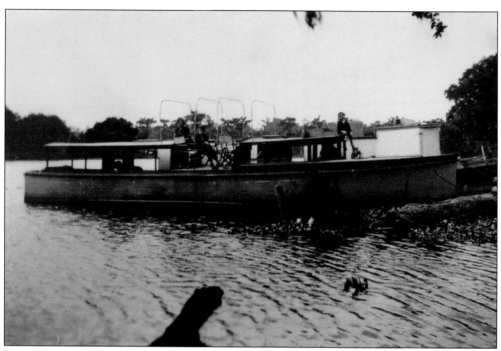

Back in the logging days, this boat was used to haul loggers to the area where they would chop down trees. They also used the boat to bring the logs down the bayou to the sawmill in Belle River. Sulia Gaudet owned the sawmill, and it is believed that this was his boat. (Courtesy of Winston and Audrey Landry Michel.)

Sulia Gaudet Sr. sits on the front of his boat. Gaudet was a very busy man, and used the boat for many tasks: delivering lumber, mail, and groceries, and checking on land to lease for cutting trees or drilling for oil. (Courtesy of Winston and Audrey Landry Michel.)

Four

COMMUNITY ESTABLISHMENTS AND REMEMBRANCE

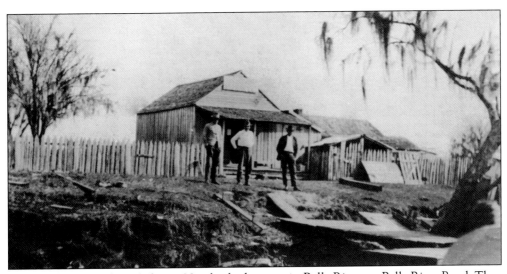

Willy and Mary Helena Ackman Vaughn had a store in Belle River on Belle River Road. They had four children: Camella Vaughn Carpenter, Letitia Vaughn Michel, Beaughard, and Alden Vaughn. They only carried the necessary groceries a family needed and bought fish, moss, and fur in season. (Courtesy of Grace Vaughn Dupre.)

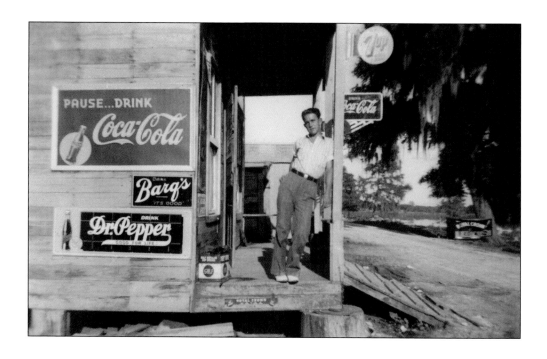

Sulia Gaudet Sr. ran a store next to his lumber mill. He would trade for moss and fur at the store, while some groceries and shoes had to be bought with Army ration coupons like other stores around the area. (Both, courtesy of Winston and Audrey Landry Michel.)

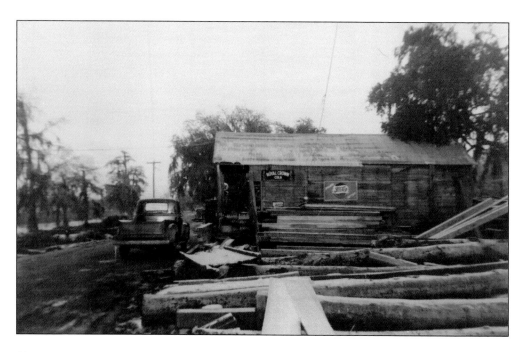

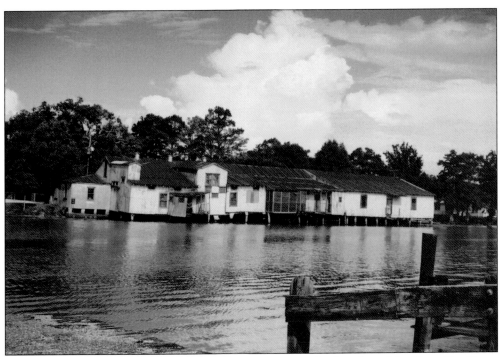

Honore "Nore" St. Germain Sr. and Alcee Fournerette were the founders of the Pierre Part Store, established in 1911. Nore married Winnie A. St. Germain and had two children: Honore "Sug" St. Germain Jr. and Bessie St. Germain Cavalier. With the passing of Winnie, Nore married Angele G. St. Germain. Nore gave the store to his son Sug. In the early 1960s, it had a bus that would go through the community to sell groceries. As the demand for more items increased, the store outgrew its location on North Bay Road. In 1968, Sug built a new store on Highway 70, and expanded in 1985. The store is now a one-stop shopping center with groceries, a deli, bakery, meat department, produce, gifts, florist, housewares, hardware, and lumber. It operates today with Sug's children as owners with their spouses. Pictured here is the original Pierre Part Store that once stood along Pierre Part Bay. (Courtesy of Tilsey Fryou Daigle.)

This is a photograph of the interior of the old Pierre Part Store on North Bay Road, taken by Effie Landry in 1955. Pierre Part Store had just about everything a family would need. (Courtesy of Effie Landry.)

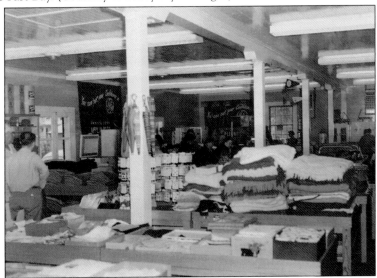

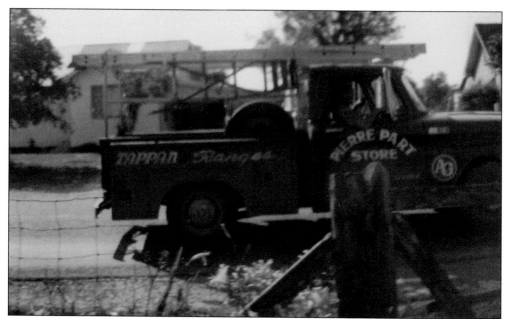

The Pierre Part Store repair truck makes a house call in June 1966. It is unknown who was driving the truck. The store had three good repair men: Norbert Breaux, Eugene Mabile, and Edley Templet. House calls were one of the many things the Pierre Part Store offered for the people in Pierre Part. (Courtesy of Moise and Ann Landry Breaux.)

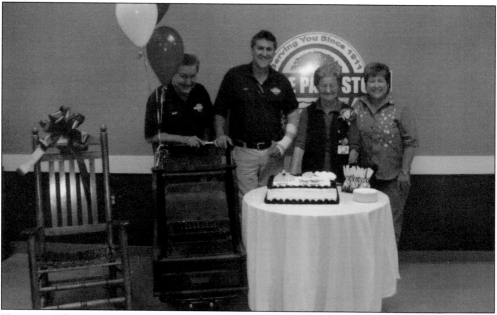

Honoring Effie Landry for 60 years of service are, from left to right, Gerald St. Germain, Kenneth St. Germain, Effie Landry, and Audrey St. Germain Guillot of the Pierre Part Store. Gerald, Kenneth, and Audrey are the children of Sug St. Germain. On February 1, 2012, Effie was surprised with a party. She started working for the St. Germains at the age of 15, and as of this writing, Effie still works for the Pierre Part Store. She started working when the store was on North Bay Road. (Courtesy of Effie Landry.)

Gervais Mabile started out selling bread. He would go to the bakery in Napoleonville to pick up bread, along with milk and newspapers, and deliver them house to house from Grand Bayou to Pierre Part. His daughter Lillian Mabile Chedotal began working for Aimar Guillot in his store at the age of 12. Guillot closed the store during World War II because of rationing, and Lillian and her father started selling bread without a license. They were reported, but soon bought a license and started selling out of their kitchen, closing in the front porch when they outgrew that. Eventually, Aimar Guillot rented them his store but went back into business when the war ended. Gervais Mabile then rented a building from the Russos, and in 1949, bought the property. Lillian and her husband, Lester Chedotal, bought the store and changed the name to Chedotal's Grocery. Chedotal's was the first business in Pierre Part to have a bakery, registers with scanners, and a post office. Lillian is pictured here in her father's store. (Courtesy of Lillian Mabile Chedotal.)

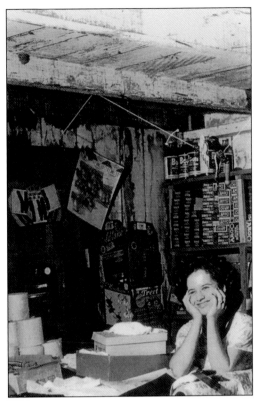

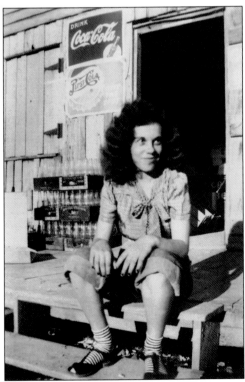

Eve Metrejean St. Germain sits on the steps of Mabile's Grocery on North Bay Road. (Courtesy of Lillian Mabile Chedotal.)

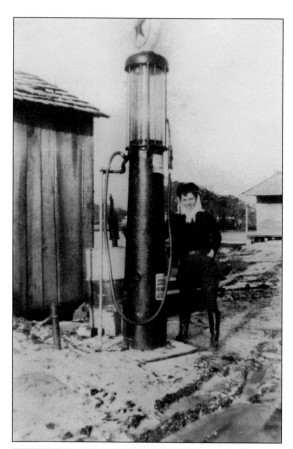

Lillian Mabile Chedotal, age 16, stands next to a gas pump at her father, Gervais Mabile's, store on North Bay Road. Lillian started working for her father after school and on weekends at the age of 12. Pictured below is the store that Gervais bought and sold to Lillian and her husband, Lester Chedotal. The store had a walkway going from the store to their house. Pictured here is Curtis "Brother" Chedotal sitting on the steps. Brother died at the age of 13 in an automobile accident. (Both, courtesy of Lillian Mabile Chedotal.)

Adeole Landry (left) and Gerald Fryou Sr. stand next to a car in front of Gervais Mabile's grocery store down the bay. Fryou lived up the road from the store, and Landry lived in Little Brule, which is now off of Highway 70. (Courtesy of Lillian Mabile Chedotal.)

In 1973, water flooded Lester and Lillian Chedotal's factory located across from Chedotal's Grocery. They bought and sold fish, turtles, crawfish, and raccoons. The water was high enough to ride a pirogue, so at least the children had fun. (Courtesy of Lillian Mabile Chedotal.)

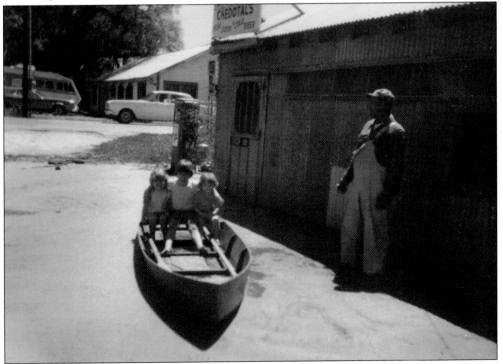

Pictured here is the building that Wiltz Landry owned on the bayou side across from the church. In the early 1940s, it was used for a crab factory. When the factory closed in the 1950s, Landry sold it to Lester Chedotal. Later, Chedotal turned the building into apartments, which are still open today. (Courtesy of Moise and Ann Landry Breaux family.)

In 1930, Elton Gaspard opened a store in his house. His 10-year-old son, Chester, worked with him. Gaspard closed the store in 1957, and Chester and his wife, Flavia Gaudet Gaspard, bought a building from Randolph Gaudet, Flavia's brother, to open a store. They named it Gaspard Grocery, and Chester and Flavia retired in 1982 after 25 years in business. Their sons Horace and his wife, Debra Domingue Gaspard, and Grady and his wife, Darlene "Dolly" Sedotal Gaspard, kept it open for six and a half more years. Becky Daigle reopened the store for three years with the name Becky's Grocery. (Courtesy of the Chester Gaspard family.)

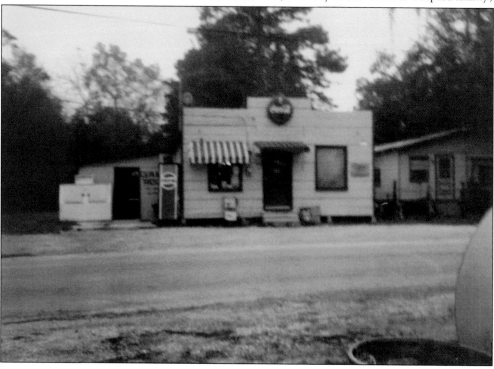

This was once known as Phillip Sr. and Alida Breaux Blanchard's grocery store. It was located along the old Highway 70 (Lee Drive) near the bayou. Phillip Jr. "P.J." worked with his family at the store, but in December 1967, they opened up a much larger store right down the road. They named it Blanchard IGA Super Market, and P.J. closed it in 1997. Both stores are pictured here. (Both, courtesy of Zara Daigle Blanchard.)

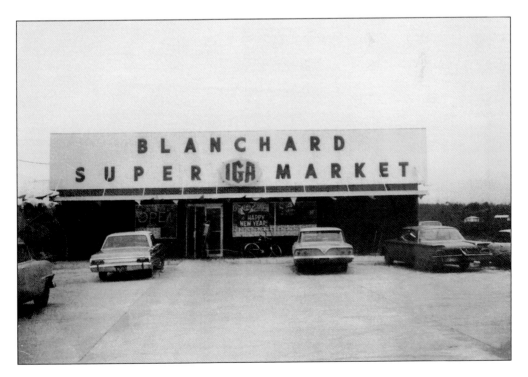

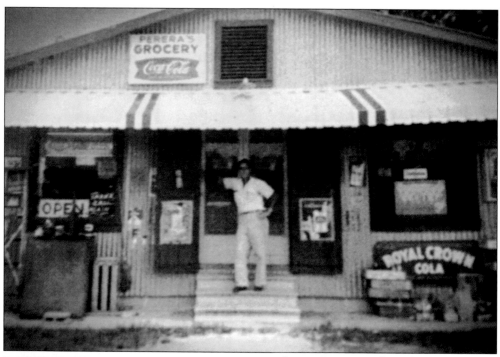

Jimmy Perera stands in the doorway of Perera's Grocery. It was located at the beginning of Godell Road (Belle River Road). Jimmy opened the store in 1959, and his son Rodney Perera took over in the mid-1970s. Rodney closed the store for good in 1990. (Courtesy of Monica Crochet Sevin.)

Jimmy Perera sits by the bank of the Belle River on the Godell side in the mid-1930s. It is likely that he is waiting on a ride by boat. He was dressed in his Sunday best. Jimmy was born on November 6, 1909. (Courtesy of Grace Vaughn Dupre.)

Brent Cox Sr. opened the Cox Theatre in 1948. It cost 31¢ for an adult and 9¢ for children. In the early 1950s, the theatre was visited by Elvis Presley, Roy Rogers, Gabby Hayes, and Johnny Mack Brown. Many people did not have automobiles; some came by boat or rode the Dixie Bus, driven by Hubert Daigle Sr. On Sunday evenings, he would go from Belle River to Bayou Corne and pick up people who wanted to go to the theater. Pictured here is Brent Cox Sr. in front of his theater. (Courtesy of the Moise and Ann Landry Breaux family.)

In the 1950s, Dairy Queen was a popular place for po-boys and cola. This photograph captures Euphemie "Mim" Guidry Cox standing on the side of the building. Mim and her husband, Brent Cox Sr., owned the business. The Dairy Queen was located where Cajun Land Realty is located today. (Courtesy of Joan Cox Landry.)

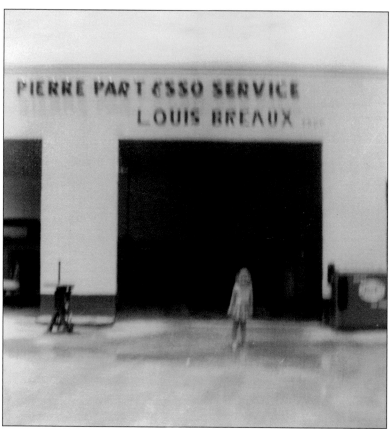

Pierre Part Esso Service Station opened in 1958 and was owned by Louise Breaux Sr. In 1969, Louis Sr. changed from Esso to Exxon. He then sold the station to his only son, Louis Breaux Jr., in 1981. Louis Jr. changed from Exxon to Chevron in 1986. The station is still open today, for oil changes only. Monica Gros Aucoin stands in front of the station in the late 1960s. (Courtesy of Geneva Breaux Gros.)

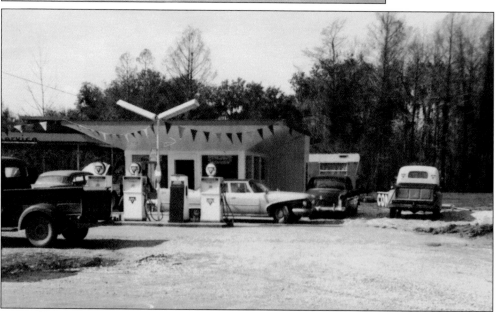

Pictured here is the Conoco Station, owned by Ivan and Carry Hebert in the early 1960s. The station was located were Pierre Part Tires was, and one could get gas, fix a flat, or have general vehicle repairs performed. Ivan was always there to get the job done. (Courtesy of Effie Landry.)

Duffy Sr. and Myrtle Matherne Landry opened a gas station in 1963. Pictured here is the L & M Gas Station. Duffy and Myrtle lived in the house on the right. In later years, business increased, and the name changed to Duffy's Shell Station. Their four sons are Troy, Ricky, Duffy Jr., and Guy. The boys all work in the business. Along with selling gas, they carry butane, some groceries, ice and beer, fishing and hunting licenses, and fish bait. They buy alligators and crawfish. Troy and his boys hunt alligator and have been featured on the History Channel. (Courtesy of Duffy and Myrtle Matherne Landry.)

Home Building Supply opened in 1966. It ran special promotions where customers could win a television. The Home Building Supply Store was owned by Wildy and Dudley Templet, and closed its doors in 1976. (Courtesy of Wildy and Hilda Landry Templet.)

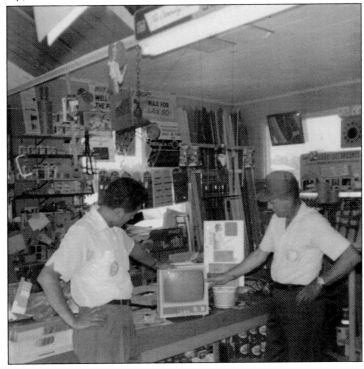

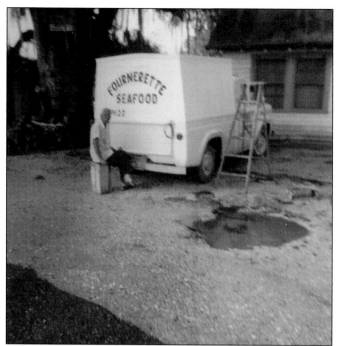

Hemlay Fournerette bought and sold seafood. His truck is parked by the Rainbow Inn Apartments under the oak trees in June 1961, but it is unknown if it is Fournerette sitting next to the truck. (Courtesy of Georgiana Cavalier Cox.)

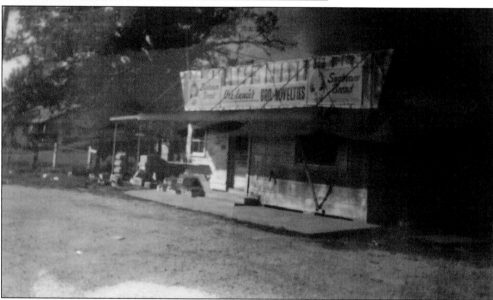

Henry Tourere and Adele Mabile Tourere's daughter Annie Tourere Giroir was an exceptional seamstress. She loved to sew, and her father put a building up across from Pierre Part School in 1954 for her to sew and sell sewing supplies. Uyless Comeaux asked her to put a few canned goods in the store, and they started adding things until it became a grocery store named Annie's Groceries and Novelties. It was very convenient for the school and the surrounding families that were within walking distance. Annie and Uyless worked the store until Celeste Dugas Bond bought it. She kept it open about one year, and Roy Richard and Lucy Sedotal Richard bought it from Celeste in January 1985. They named it Bayoulands Grocery and closed it in April 1992. (Courtesy of Celeste Dugas Bond and Eddie Dugas.)

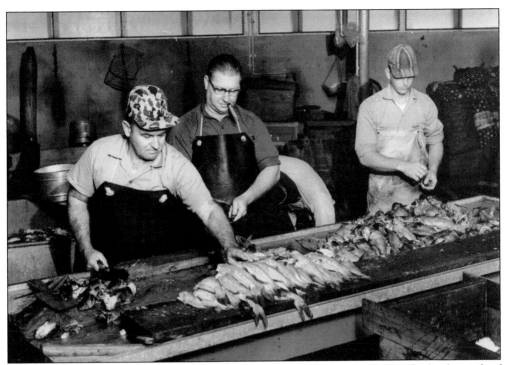

These men are cleaning catfish at Breaux and Daigle's fish dock in 1960. Hundreds of pounds of catfish were pressed in this fish dock daily. From left to right are Roy Theriot, Kelly Daigle, and Alex Hebert. Breaux and Daigle was a family business. (Courtesy of Levie Gaudet Theriot.)

Pictured here in 1972 is Landry's Fried Chicken. Mitchell and Lucy Daigle Landry and their son Lloyd "Buddy" and his wife, Ceola Wiggins Landry, were the owners. In 1984, they built a new building and changed the name to Landry's Seafood Restaurant. (Courtesy of Penny Landry Lambert.)

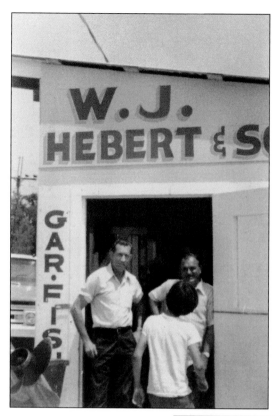

Wilbert Hebert and Joseph "Joe" Daigle became business partners in W.J. Hebert and Sons Seafood. A few years later, the name changed to Hebert and Daigle Seafood. As business grew, they enlarged the building. It was a seafood processing plant; however, they bought and cleaned catfish and turtle as well. Hundreds of pounds of crabs and crawfish were picked in this plant daily and shipped all over. Pictured here are Wilbert (left), Joe (right), and Kevin "Crook" Daigle with his back to the camera. (Courtesy of Verna Boudreaux Hebert.)

These woman are crab picking at Hebert and Daigle's Seafood. Some picked crabs and some picked the claw meat. It is believed that Katie Smith (at left, with the hat) was picking claws, and Olen Watson and Beverly Dangerfield on the other side of the table were picking the crabs. (Courtesy of the Moise and Ann Landry Breaux family.)

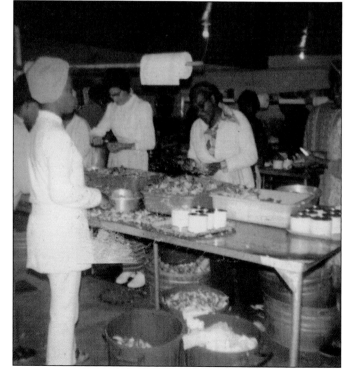

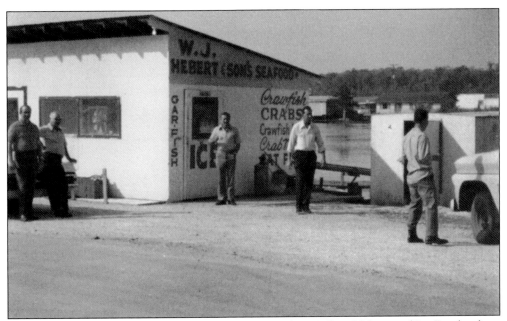

The seafood plant was at the foot of the Belle River Bridge. Wilbert Hebert and Joe Daigle, along with their wives, worked at the plant. Verna, Wilbert's wife, took care of the books and Marion, Joe's wife, managed the kitchen. Pictured here are Carol Domingue Sr. (right), who drove the truck to pick up crabs, Wilbert (walking towards Carol), Bill King at the door, and two unidentified men leaning on the vehicle. (Courtesy of Verna Boudreaux Hebert.)

Wilbert Hebert and Joe Daigle would ship their crab meat to Baltimore, Maryland, to Sea King Seafood. Pictured here from left to right are Calvert Jolly, unidentified, Sea King Seafood owner Bill King, and Joe Daigle. King had come down to Louisiana to visit the plant. (Courtesy of Verna Boudreaux Hebert.)

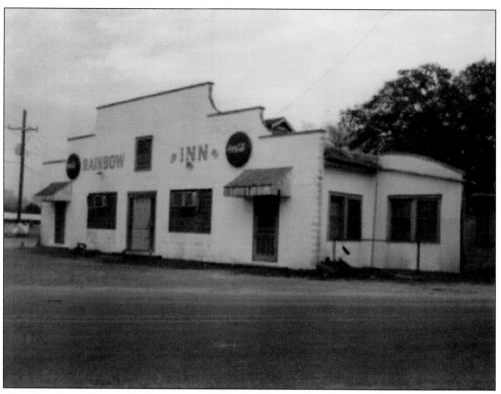

The Rainbow Inn bar and restaurant is one of the oldest places in Pierre Part. It was built by Honore St. Germain Sr. and opened July 4, 1938. The original façade was shaped like a rainbow; it is unknown when the front was changed. Honore gave the Rainbow Inn to his daughter, Bessie St. Germain Cavalier, who married Clerfe "Pete" Cavalier. Percy and Annett Blanchard Matherne had the first wedding dance in the Rainbow Inn on August 13, 1938. People traveled from near and far to enjoy themselves here. Nicky and Koonie Chedotal Ourso bought the Rainbow Inn in 1990. (Courtesy of Nicky and Koonie Chedotal Ourso.)

Pictured here is the Rainbow Inn parking lot between the late 1950s and early 1960s. (Courtesy of Georgiana Cavalier Cox.)

Pictured here in July 1961 are, from left to right, Blanch Templet, Eve Alleman, and Odette Landry. They made the best stuffed crabs around, and people came from all over to eat at Rainbow Inn. (Courtesy of Georgiana Cavalier Cox.)

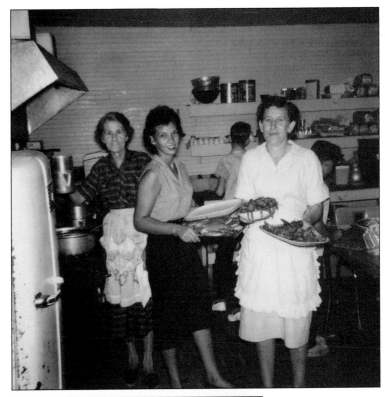

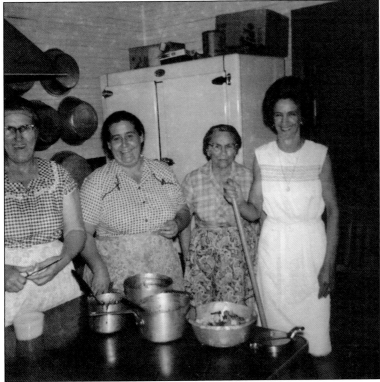

Pictured here from left to right are Rosa Berthelot Templet, Selma Breaux Pintado, Lorena Sedotal Landry, and Ester Gauthreaux working in the Rainbow Inn kitchen in September 1967. These ladies are just some of the kitchen workers from the Rainbow Inn. (Courtesy of Georgiana Cavalier Cox.)

Pictured here in the kitchen of the Rainbow Inn are, from left to right, (first row) Ann "Taunt Non" Landry, Elta Verret, Dianne Landry, and Bessie St. Germain Cavalier; (second row) Elta "Tat" Gauthreaux Domingue, Mary Jane Blanchard Broussard Kirkland, Brenda Sedotal, and Rosa Berthelot Templet. (Courtesy of Georgiana Cavalier Cox.)

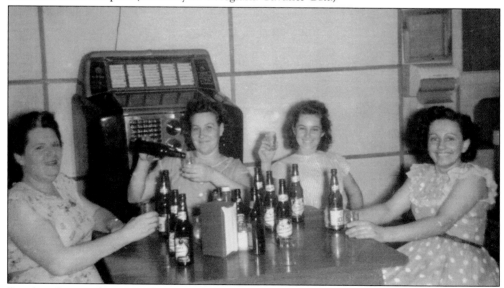

Rainbow Inn employees are having a few drinks after work. Nothing is more relaxing than good music and a drink with friends. In this photograph are, from left to right, unidentified, Pearl Theriot Fournerette, Mercedes ?, and Hazel Sedotal. (Courtesy of Levie Gaudet Theriot.)

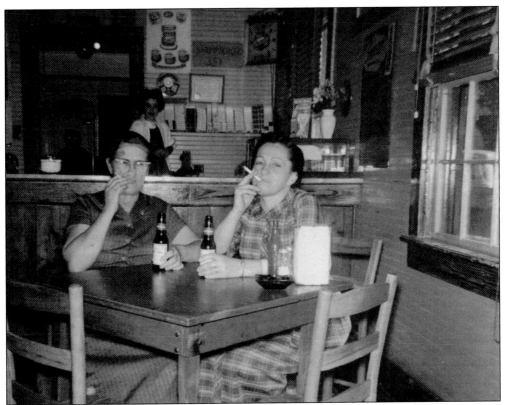

In January 1962, Rosa Berthelot Templet and Hazel Breaux appear as if they are taking a cigarette break. They are two of the kitchen workers at the Rainbow Inn. The cooks had to work very hard because it was a favorite eating place for many people. (Courtesy of Georgiana Cavalier Cox.)

From left to right are Samuel Breaux, Ursula Daigle Breaux, Honore Breaux, and an unidentified man eating at the Rainbow Inn in May 1967. (Courtesy of Georgiana Cavalier Cox.)

Eating boiled crabs at the Rainbow Inn are, from left to right, Jimmie Cavalier, unidentified, Paul Templet, Rosa Templet, Hazel Sedotal, Virgie Lee Cavalier Settoon, and Randy Cavalier. The Rainbow Inn served boiled crabs and crawfish in season. (Courtesy of Georgiana Cavalier Cox.)

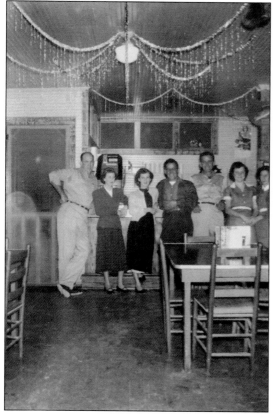

From left to right are Claude "Sho Sho" Cavalier, Beverly Breaux Mabile, Dora Cavalier Richard Guillot, Gerald Richard, Eldrige "Nookie" Rodrigue, and two unidentified women. They are in the restaurant at the Rainbow Inn, likely around the New Year based on the décor. (Courtesy of Georgiana Cavalier Cox.)

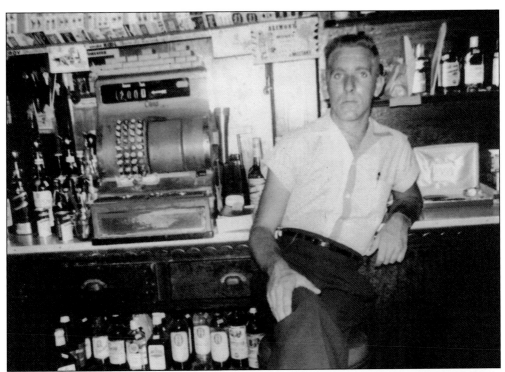

Bartender Larry Rodrigue sits behind the bar at the Rainbow Inn. Larry and his brother Eldrige "Nookie" Rodrigue both worked at the bar. (Courtesy of Georgiana Cavalier Cox.)

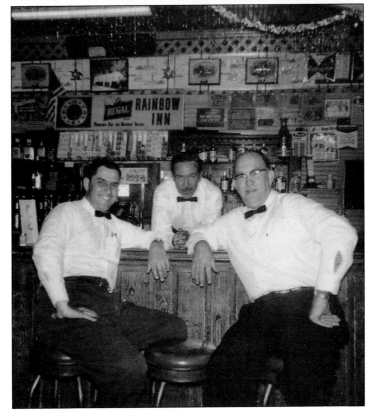

From left to right, Jessie Dugas, Jimmy Cavalier, and Sho Sho Cavalier were some of the bartenders at the Rainbow Inn. Jimmy's mother, Bessie St. Germain Cavalier, owned the Rainbow Inn, a stomping ground for many people and well known by all. This photograph was taken in January 1962. (Courtesy of Georgiana Cavalier Cox.)

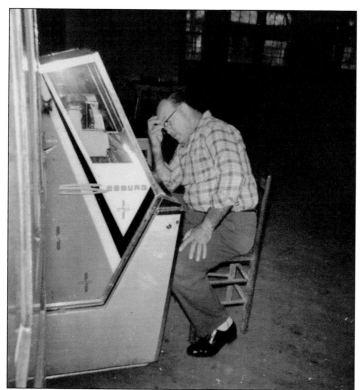

In November 1961, Sho Sho Cavalier sits in front of the jukebox at the Rainbow Inn. Sho Sho was fixing it at the time, but he looks like he was having a rough time with it. With a little thinking, he did the job. (Courtesy of Georgiana Cavalier Cox.)

Friendly card games at the Rainbow Inn were played often. Players pictured here include Brent Cox Sr., Antoine "Tan" Michel, Jessie Richard, and Paul Templet. (Courtesy of Georgiana Cavalier Cox.)

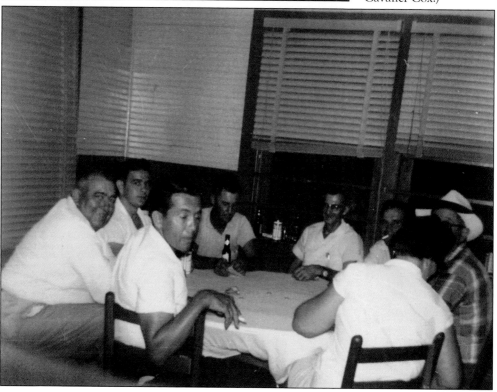

Jessie Dugas and Elodia Blanchard Cavalier are at the bar of the Rainbow Inn. Jessie worked as bartender for many years and was just coming in to work. Elodia was a sweet lady, loved by all. (Courtesy of Georgiana Cavalier Cox.)

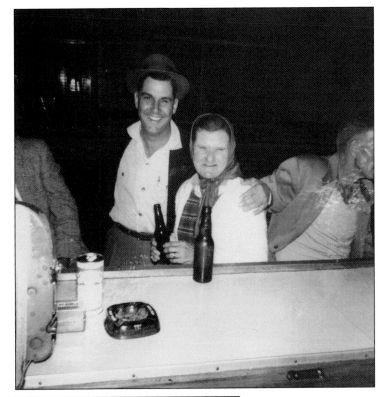

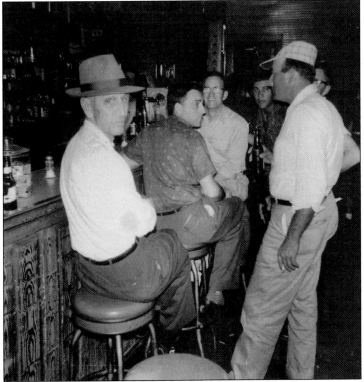

One could always find a friend at the Rainbow Inn, pictured here in the late 1950s. It is believed that the man on the bar stool facing the camera is Addison Knotts, and the man with the cap standing is Floyd Blanchard. The others are unidentified. (Courtesy of Georgiana Cavalier Cox.)

Pictured here at the Rainbow Inn bar are, from left to right, Jessie Richard, Rita Mae Richard, Ella Mae Richard Landry, Calvin Landry St., Carol Domingue Sr., and Lenit Daigle. Peering above their heads in the background is Noland Hebert Jr. (Courtesy of Georgiana Cavalier Cox.)

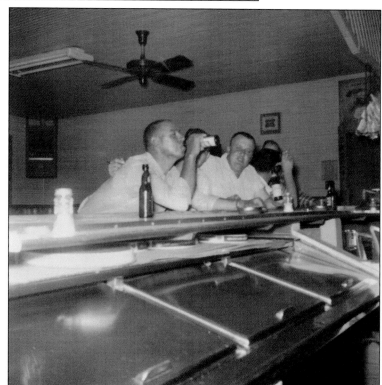

One could always get a cold beer with a friend at the Rainbow Inn. Lee Aucoin (left) and Pat Dugas are having a drink to unwind and relax. (Courtesy of Georgiana Cavalier Cox.)

Having a few drinks and a laugh with friends at the Rainbow Inn are Dr. Jerome Bernard Peltier and his wife, Mary Elizabeth Rainey Peltier. Peltier opened his practice in 1956 in a small office next to the pharmacy, which was located by the theater and Dairy Queen. In the 1960s, Peltier and the owner of Richard's pharmacy decided to build a new pharmacy and a small, three-bedroom hospital on old Highway 70 (Lee Drive), where a daycare is today. Peltier continued to practice medicine until 1972. (Courtesy of Georgiana Cavalier Cox.)

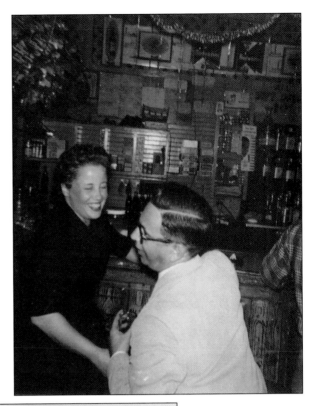

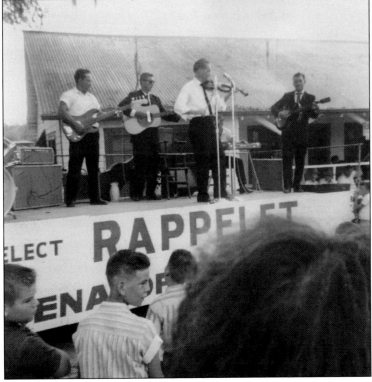

Election time was always a busy time for the Rainbow Inn. Many candidates held rallies there, and would come to speak to the people and host a free supper and music. (Courtesy of Georgiana Cavalier Cox.)

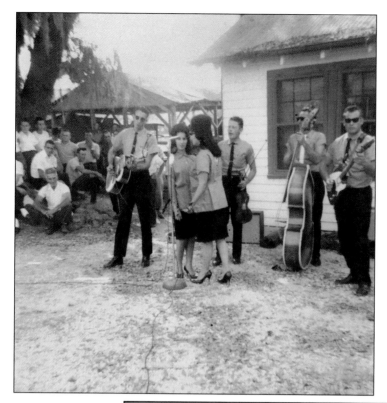

A band plays under the trees at the bayou side at the Rainbow Inn Apartments. Lots of people came to listen to bands at the Rainbow. It is unknown if they were actually playing or just practicing. (Courtesy of Georgiana Cavalier Cox.)

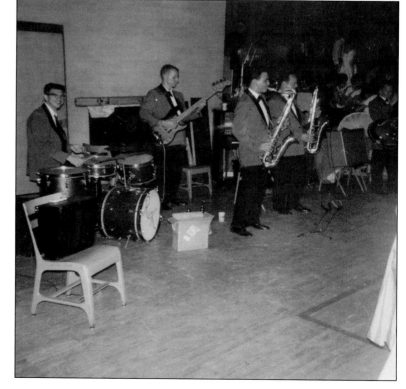

It was June 1962 when this band played at the Rainbow Inn. Bands came from all over and enjoyed playing at the inn, where everyone was guaranteed a good time. (Courtesy of Georgiana Cavalier Cox.)

The Richard Brothers were a country and western band. They played honky-tonk and swamp pop music. Norris Richard, their uncle, played the drums, Golen Richard lead guitar, Lester Richard guitar, and Gerald Richard bass guitar. They even sang French songs. Vincent "Cy" Tortorich played a saxophone. He taught Lester and Carol how to play the sax, and Cafray Richard (son of Norris) and Nelson Blanchard joined the band in 1960. Lester was in charge of collecting the money and giving everyone a share. Dance halls would have jitney dances, where each dance was paid for individually. They roped off a dance floor, sold tickets for 10¢, and when a song began, dancers could move to the floor. For weddings they would make $18 each. (Courtesy of Georgiana Cavalier Cox.)

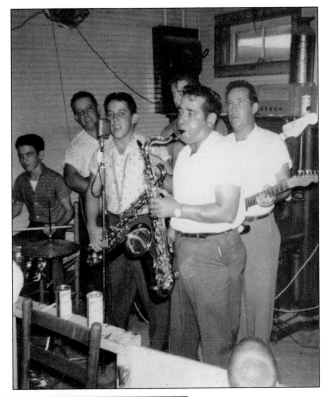

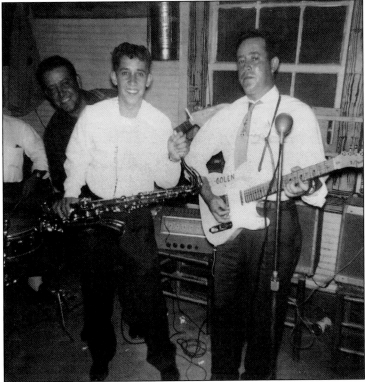

Gerald, Carol, and Golen, the Richard Brothers, are playing the Rainbow Inn in the early 1960s. Carol started playing at the age of 18. (Courtesy of Georgiana Cavalier Cox.)

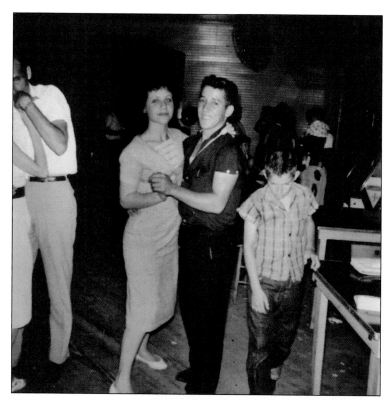

Carol Richard (in black) loved to dance; he is pictured here dancing with Mary Gail Chedster. The Richard Brothers were playing music that night, but Carol must have taken a break to dance. Carol passed away on January 8, 2014, at the age of 72. He was the last of the Richard brothers. (Courtesy of Georgiana Cavalier Cox.)

Everyone would have their wedding dance at the Rainbow Inn. This is Cecile Rivere, Richard Dupuy, and Joseph "Poppa Toon" Dupuy's wedding dance. Cecile was the mother of Richard brothers Golen, Gerald, Lester, and Carol; she also had two daughters, Florence "Flo" Richard Landry and Ann Eve Richard Guillot. They were married in June 1960. (Courtesy of Georgiana Cavalier Cox.)

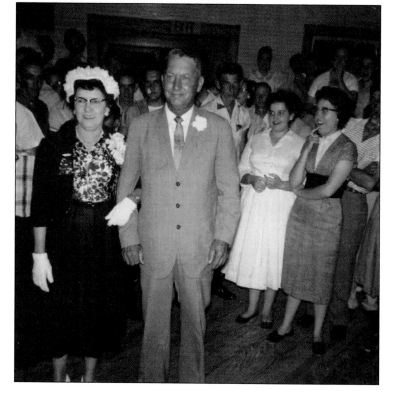

There was always someone looking for a dance partner at the Rainbow Inn. This young lady, likely doing the twist, looks like she is having a good time. (Courtesy of Georgiana Cavalier Cox.)

This group was having a lively time at the Rainbow Inn. Clockwise from left are Claynes Breaux, Laurine Daigle, unidentified, Kelly Daigle, Chester Pipsair, Lula Mae Daigle Pipsair, Anita Daigle Breaux, Anne Mabile Giroir, and an unidentified couple. (Courtesy of Georgiana Cavalier Cox.)

Mertile LaJaunie and Beulah Breaux LaJaunie are having a few drinks with friends at the Rainbow Inn. Going to the Rainbow was an outing for many people. (Courtesy of Georgiana Cavalier Cox.)

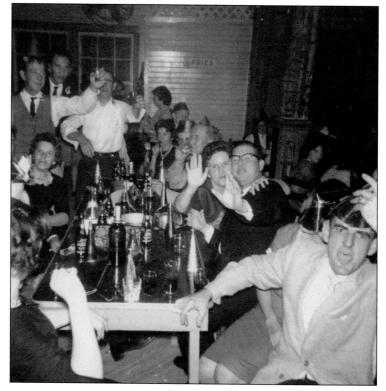

Good times were always to be had at the Rainbow Inn. Pictured here clockwise from left are Eunice Daigle Frieze, Melvin Richard, ? Hue, Jerry Daigle, Lucy Cavalier Daigle, Anita Daigle Breaux, Claynes Breaux, Lorraina Daigle Daigle, Kelly Daigle, and Shelby Giroir. (Courtesy of Georgiana Cavalier Cox.)

This must have been a wedding dance, because everyone is dressed up. The woman with her hand up in the white dress is Orville "Coo-Coo" Mabile Acosta. All the rest are unidentified. This photograph was taken in May 1962. (Courtesy of Georgiana Cavalier Cox.)

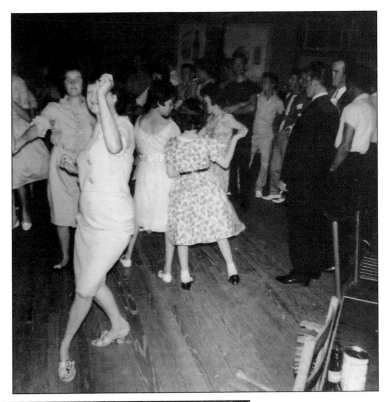

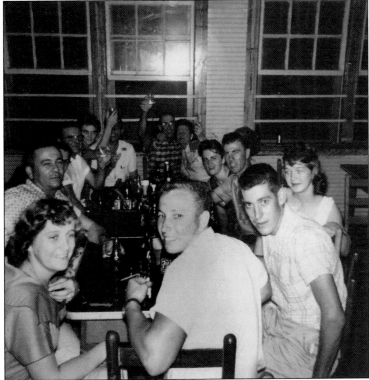

The people in the foreground are, from left to right, Hilary Richard, Loretta Crochet Richard, ? Acosta, Lloyd Broussard, and Mary Jane Blanchard Broussard Kirkland; the people in the back are unidentified. They all seem to be having a great time at the Rainbow Inn. (Courtesy of Georgiana Cavalier Cox.)

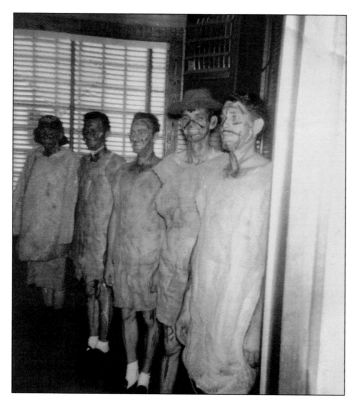

It was Mardi Gras at the Rainbow Inn. Mardi Gras night was the last night that people could dance until Easter Sunday, a tradition that was passed down by the people's French ancestors. They always had a dress up contest, and it was a good time for everyone. These costumes seem to consist of sacks and painted faces. Things were simpler back then; people enjoyed themselves and made do with less. (Courtesy of Georgiana Cavalier Cox.)

Rainbow Inn was the party place to be around Mardi Gras. Both men and women loved to dress up and have a great time. From homemade to store-bought costumes, everyone was ready for Mardi Gras. (Courtesy of Georgiana Cavalier Cox.)

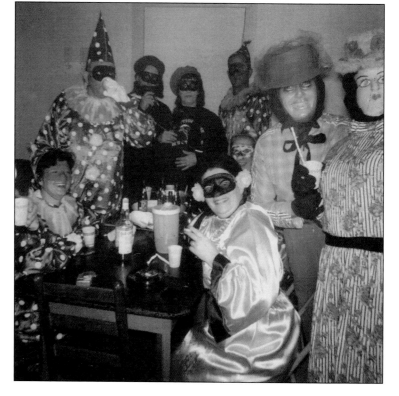

Mardi Gras was always fun for Claude "Sho Sho" Cavalier; he loved to dress up. Sho Sho (left) and Nookie Rodrigue sat on the porch to take this photograph. It was never a dull Mardi Gras with Sho Sho around. (Courtesy of Georgiana Cavalier Cox.)

Sho Sho poses in his backyard in Belle River all dressed up again. Sho Sho would dress up every year for Mardi Gras and parade up and down the streets. He always wore homemade costumes. (Courtesy of Georgiana Cavalier Cox.)

In the 1960s, Camp Bayou Corne was built by Jim DeGregory. It was a beautiful place where one could have a good time, featuring a great restaurant, a nice bar, a public swimming pool, a boat launch, and a large dance hall for special events, particularly Sunday bingo. It also served as a campground, bringing in many people from all over. (Courtesy of the Moise and Ann Landry Breaux family.)

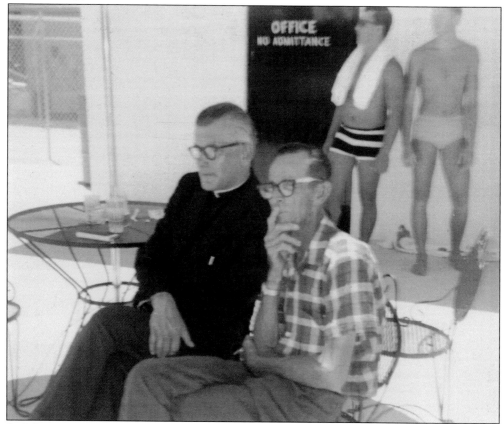

Fr. John T. Martine and Lee Gaudet Sr. were relaxing at Camp Bayou Corne's pool. This was a place where one could eat, swim, and relax. This photograph was taken in the summer of 1968. The pool was open to the public, but a small fee was charged to swim. (Courtesy of Georgiana Cavalier Cox.)

These ladies were having a good time at Camp Bayou Corne. In the early 1970s, Warren Storm and his band came to perform at Camp Bayou Corne. From left to right are (first row) Doreen Richard Gregoire Breaux, Warren Storm, and Barbara Chedotal Richard; (second row) Linda Lou Pellegrin Blanchard Wyth and Audrey Domingue Lacosta. (Courtesy of Audrey Domingue Lacosta.)

From left to right, Audrey Domingue Lacoste, Van Bruce, and Linda Lou Pellegrin Blanchard Wyth are at Camp Bayou Corne. It was always a thrill to go onstage and talk to the band. (Courtesy of Audrey Domingue Lacoste.)

In September 1979, the Big Tap held its grand opening. Pictured here playing for the grand opening is new band The Cajun 4 (from left to right) Iris Callegan (keyboard), Carol Gauthreaux (bass guitar), Phillip "Phill" Richard (guitar), and Donald "Don Rich" Richard (drums). First cousins Don and Phill started playing the guitar after the passing of Don's father, Golen Richard, when Don was 11 years old. He was given his father's guitar. Pete Cavalier, owner of the Rainbow Inn, came to get the guitar from Don, because his father hadn't finished paying for it. Pete sold the guitar to Steve Cedotal, and one day, Steve called Don and said "I think I have something you might want." Don was very happy to have his father's guitar back. Phill helped Don in many ways, and they are both musicians today. Don had his dad's guitar restored to its original condition and keeps it in a safe place. He will always treasure it. As Don's love for music grew, he learned to play seven different instruments. Donald, known as Don Rich, is as famous as the Richard Brothers were in the 1950s. (Courtesy of Barbara Sedotal Richard.)

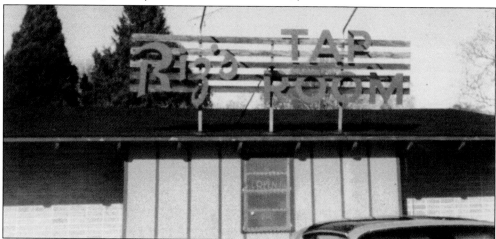

Riz's Tap Room was owned by Risley Mabile. It was located across from the Rainbow Inn, not too far from the theater. It was better known as the Lil Tap. The tap room was small in size, but many people crowded the bar room every weekend. (Courtesy of Shoni Ponville Hebert.)

From left to right, Roy Hebert, LeRoy McAdams, and Howard Metrejean have a friendly drink at the Lil Tap. (Courtesy of Shoni Ponville Hebert.)

Back in the early 1970s, these men loved to drink their Schlitz beer. They are at the Lil Tap, one of their favorite watering holes. From left to right are unidentified, Wilbert "Bert" Landry, Medward "Wine" Ponville, Floyd Daigle, Albert "Doo" Foret Sr., and LeRoy McAdams. (Courtesy of Shoni Ponville Hebert.)

Faye "Effie" Ponville and her friends are pictured at Riz's Tap Room in 1970. From left to right are (first row) unidentified, Laurie Hue, Ronald Blanchard, and Irvin Breaux; (second row) Effie Ponvile and Susan Breaux Lacoste. (Courtesy of Shoni Ponville Hebert.)

Alex and Aimae Blanchard Crochet's little house is located on North Bay Road. Alex built a bigger house next door and let his daughter Julie and her husband live there; however, Julie passed away, and her husband moved out. Alex made an ice shop out of the house, and they would make homemade ice cream to sell. They started hosting card games in the back room when the shop was closed. Percy Matherne rented the building and opened a bar named the Country Club. Reno Crochet bought the place from the Crochet estate, and many people rented the bar. It was widened and a dance floor was added. Later, Harold Aucoin (pictured in the 1970s) had the bar. (Courtesy of Betty Mabile.)

Three miles down Shell Beach Road was the Old Lake Bar, which was owned by the Russo family. The Russos leased the building to many people. It had a beautiful view of Lake Verret, big, shady oak trees, a nice place to have a picnic, and a long wharf for swimming. At the time of this photograph, Percy DeLette was the proprietor. At some time, Percy called it Edd Lee's Shell Beach Club. Later, the restaurant was added. Percy bought a monkey and kept it by the oak tree; note the top of the cage. People were asked not to feed or play with it, and the monkey was removed because it became very aggressive. (Courtesy of the Moise and Ann Landry Breaux family.)

The Old Lake Bar would give free cold drinks to anyone who could walk from one end of this greased pole to the other. Here Don Breaux is walking the pole to earn a free drink. (Courtesy of the Moise and Ann Landry Breaux family.)

Throughout the years, the bar had many names and owners. Audrey Domingue Lacosta worked there for 10 years as bartender for other owners. She owned the business from 1995 until 2006, when Stevie and Yvette Domingue Gautreau bought it. The building was 100 years old when Audrey opened Chili's Bar. In 2008, Hurricanes Ike and Gustav took out the building. The place no longer exists, and is missed by many. (Courtesy of Audrey Domingue Lacosta.)

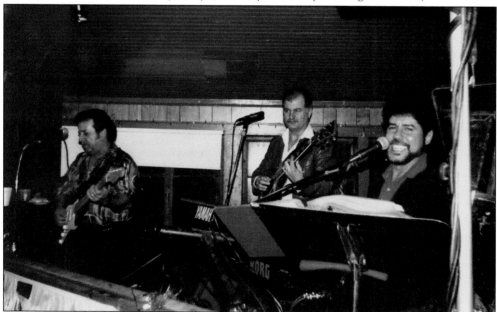

The Don Rich Band play on Christmas at Chili's Bar in the late 1990s. Don and his band rocked the place all night long. From left to right are Phillip "Phill" Richard, Ricky Guillot, and Donald "Don Rich" Richard. They would play anything, and lots of people from all over came to hear them. (Courtesy of Audrey Domingue Lacoste.)

Blanchard's Restaurant, Bar & Lounge was located on old Highway 70 (Lee Drive). Blanchard's was a hotspot for the younger crowd, and with a restaurant next door, good food was always available. (Courtesy of Fran Blanchard Landry.)

Shirby "Nookie" Sedotal Sr., a rig worker, worked on Rig No. 7. He opened a bar in Napoleonville and named it after the rig he worked on. In 1978, Andrew Metrejean Sr. sold him his bar on Shell Beach Road. A few years later, Sedotal sold the building and built a new bar. Nookie opened it in 1981 and decided to double the seven and call it Rig 14. It was then closed for good in 2002. The bar pictured is Rig 14, and it looks like Pat Dugas stopped in for a drink. (Courtesy of June Sedotal Daigle.)

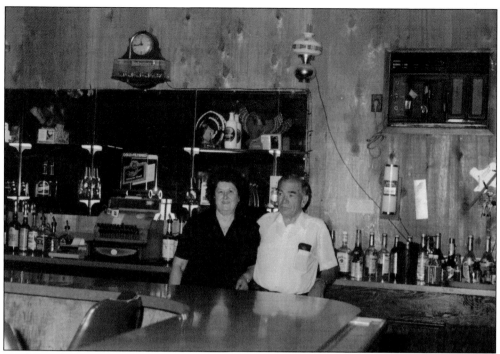

Nookie and Rena B. Sedotal were behind their bar at Rig 14. They loved to party with friends and were adored by many. Nookie passed away at the age of 72, and Rena was 86 when she passed. (Courtesy of June Sedotal Daigle.)

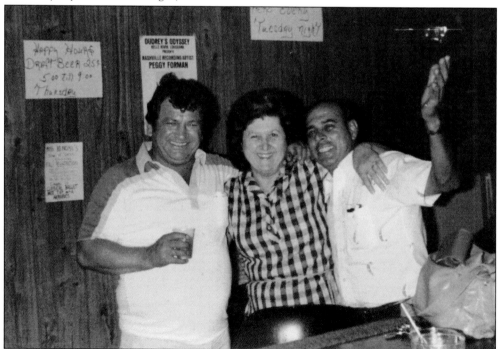

These two men always had a good time when together. Calvin Landry Sr. (left) and Shelby Gaudet (right) are having a few drinks with Rena Sedotal at Rig 14. (Courtesy of June Sedotal Daigle.)

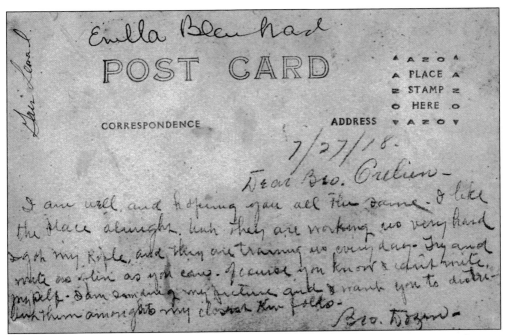

This postcard was mailed July 27, 1918. Dozillian Leonard sent it with his photograph and a letter back home. Dozillian had his friend write it, because he was illiterate: "Dear Bro. Crelien [or Grelien] I am well and hoping you all the same. I like the place alright. Huh, they are working us very hard. I got my rifle, and they are training us every day. Try and write me often as you can. Of course you know I can't write myself. I am sending my picture, and I want you to distribute them amongst my closest kin folks. Bro. Dozin." (Both, courtesy of Emelda Ackman Blanchard.)

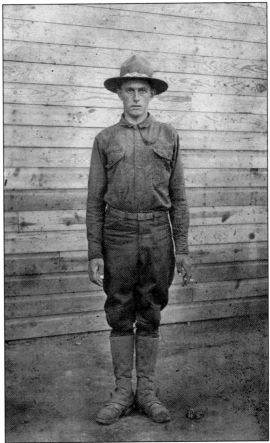

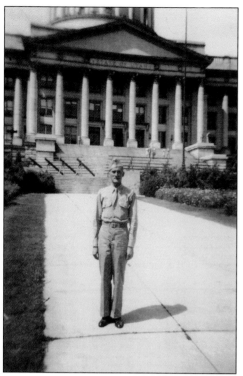

Gildy Gaudet served in World War II in the early 1940s, working with the mechanics and building airplanes. Gildy returned home and helped his father in their family business. Gildy was born February 18, 1911, and died March 21, 2002. He never married. (Courtesy of Winston Michel and Audrey Landry Michel.)

Pictured here in 1944 are World War II servicemen from the Pierre Part area. The two men in the middle are Adam Trishe (left) and Roy Theriot (right). (Courtesy of the Chester Gaspard family.)

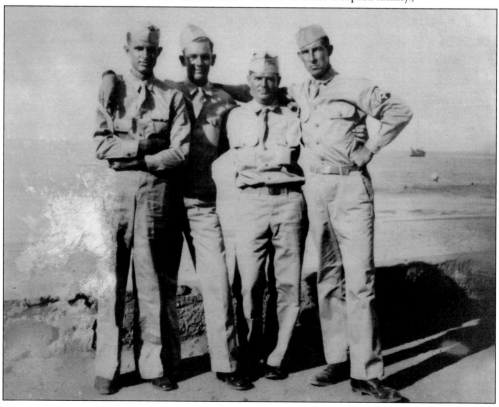

Roy Theriot, born in 1921, served in World War II. He enlisted in 1945 and departed the United States in 1948. He is pictured here sitting next to his tent. Roy traveled to many countries, including Belgium, France, and Mexico. (Courtesy of Levie Gaudet Theriot.)

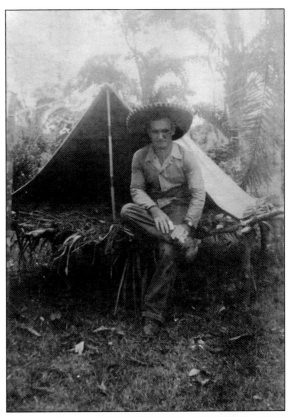

In 1943, Moise (left) and Norbert Breaux (right) had just returned home from World War II. Moise was 18 years old. This photograph was taken at the bayou near their parents' house. Moise and Norbert's father, Kennedy, had 22 children. He had 11 with his first wife, Idia Hebert, and 11 with his second wife, Eugina Aucoin. Moise was born July 9, 1925, and died March 22, 2010. In 1960, Moise was in a hunting accident, and lost his leg. (Courtesy of the Moise and Ann Landry Breaux family.)

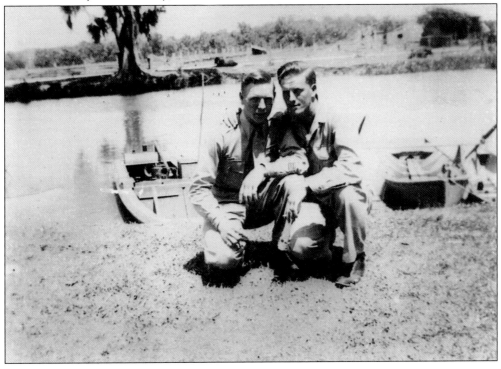

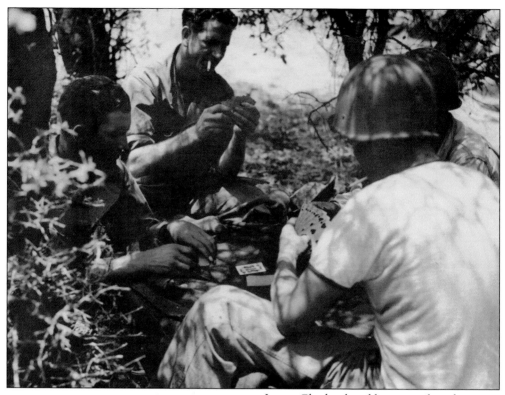

Lester Chedotal and his many friends liked playing cards. They are pictured here in North Africa during World War II. Lester is the one in the middle with a cigarette in his mouth, and the rest are unidentified. Lester was a cook in the Army, and was 19 at the time of his enlistment. (Courtesy of Lilian Mabile Chedotal.)

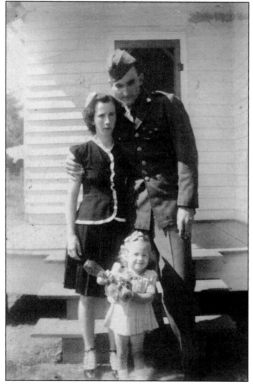

Louis Breaux served in World War II. Pictured here in 1944 are Louis, his wife, Nelia Cavalier Breaux, and their 21-month-old baby Geneva Breaux Gros; they lived in a small house on South Bay Road. (Courtesy of Geneva Breaux Gros.)

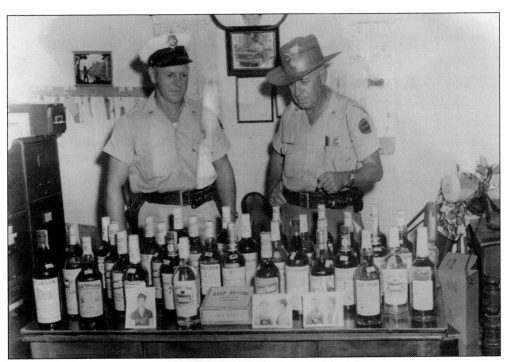

In the early 1960s, Deputy Moise Breaux and Chief Deputy Gaston Gros worked for the Assumption Parish Sheriff's Office. They made a liquor bust and confiscated over 30 bottles of liquor. It is unknown what is in the cigar box on the table. Mug shots are also visible on the tabletop. (Courtesy of the Moise and Ann Landry Breaux family.)

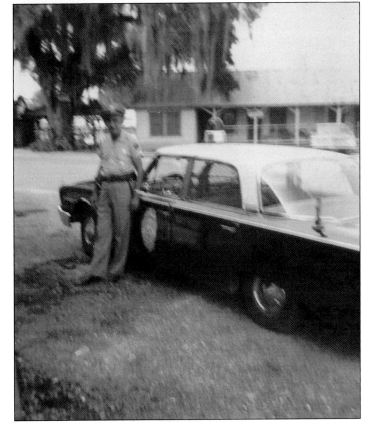

Theophile Metrejean was a water patrol worker, and when not on the water he would help out where needed. He is standing next to a patrol car in front of the Rainbow Inn. (Courtesy of the Moise and Ann Landry Breaux family.)

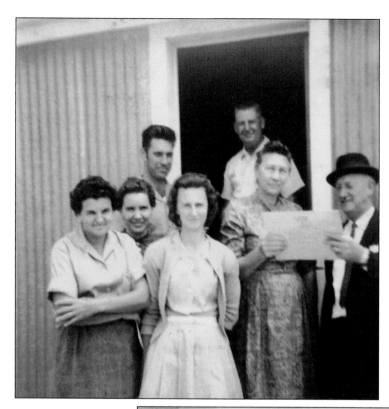

The building behind the Belle River Fire Station is used for voting. Poll workers in 1962 are, from left to right, (first row) Emelda Ackman Blanchard and unidentified; (second row) Ezella Himel, Angella Gros Lambert, and an unidentified poll official from St. Martin; (third row) Ervin Miller and an unidentified man. (Courtesy of Emelda Ackman Blanchard.)

In 1959, the first fire station was built at the foot of the Pierre Part Bridge. It was called Pierre Part–Belle River Fire Station. The first fire chief was Gipson "Gip" Gaudet (right) of Pierre Part. With him are Stanley Daigle (left) of Belle River and Tony Dugas with Depend da Craft, who was donating a check to the new fire station. (Courtesy of Karen Gaudet St. Germain.)

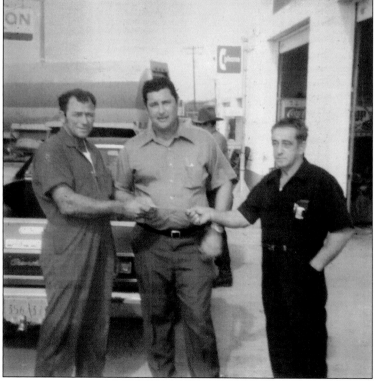

Five

SIMPLE TIMES

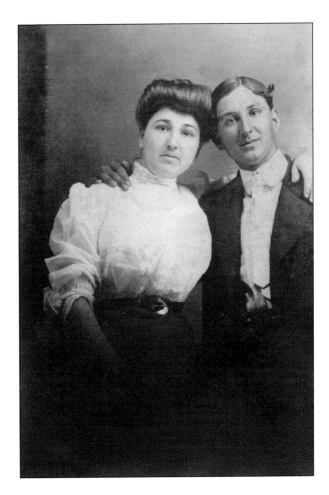

Benedict Breaux and Laurenza Blanchard Breaux are pictured here in 1880. (Courtesy of Jackie Breaux Sanchez.)

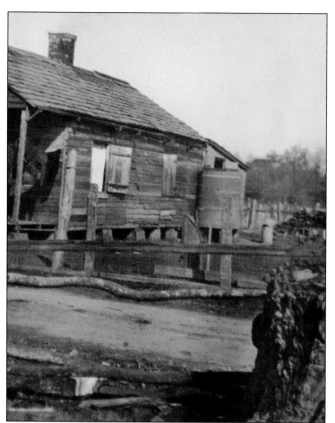

This is the home of Florian and Bernadette "Taunt Ban" Daigle Metrejean. Taunt Ban was known for making the best homemade *tart à la bouille* (custard pie). Florian died at the age of 57 in 1945, and Taunt Ban died at the age of 88 in 1982. (Courtesy of Emelda Ackman Blanchard.)

Kennedy Breaux's house is pictured here in the early 1900s. It was located along Bayou Pierre Part (Lee Drive). Kennedy married Idia Hebert Breaux, and they had 11 children. When Idia passed away, Kennedy married Eugina Aucoin Breaux, and they also had 11 children. (Courtesy of the Moise and Ann Landry Breaux family.)

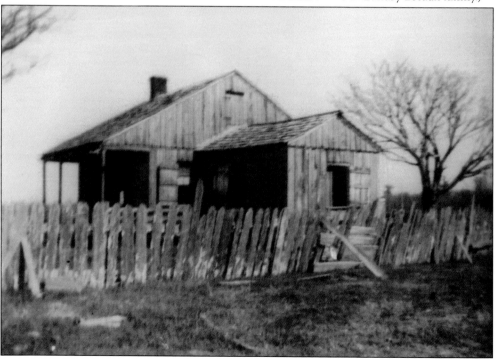

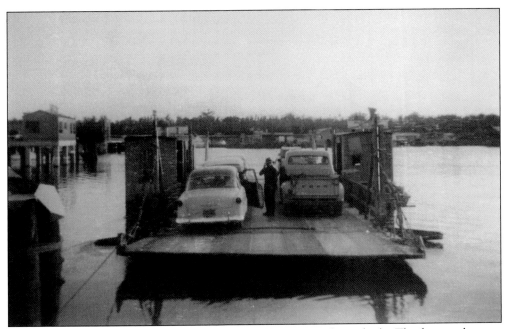

For many years, this was the only way to cross Belle River with a vehicle. The ferry took many cars and trucks from one side to the other. In 1958, a pontoon bridge, under construction in this photograph, was built over the river. (Courtesy of Georgiana Cavalier Cox.)

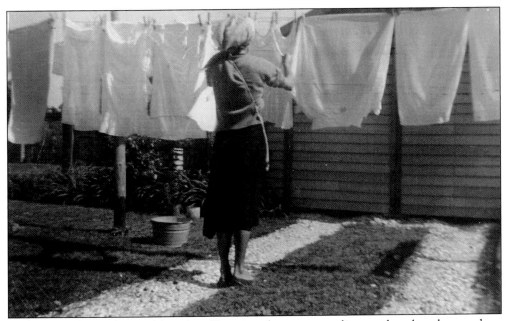

Washing clothes with a washboard and hanging them out on a line was how laundry was done in the good old days. Noeline Pipsair Cavalier is pictured here hanging out her clothes. It is unknown if she had to use a washboard or if they had a wringer washing machine. (Courtesy of Georgina Cavalier Cox.)

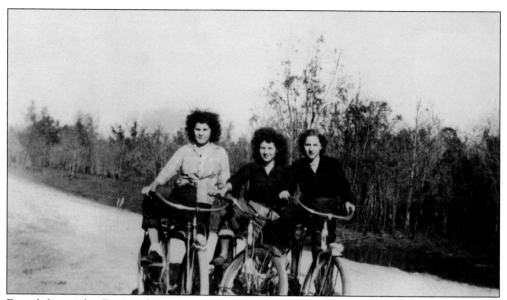

From left to right, Eve Landry Hebert, Lillian Mabile Chedotal, and Bessie Landry Leonard are riding their bicycles along the old Pierre Part Road, which is Lee Drive today. They were around 15 years old when this photograph was taken in 1944. (Courtesy of Lillian Mabile Chedotal.)

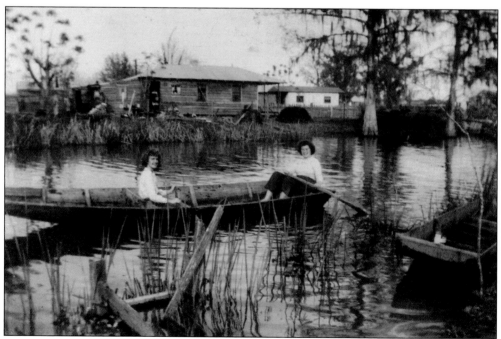

How relaxing it was to go for a ride in a pirogue. Anna Mae Landry Landry and Azile Breaux Landry enjoy a pirogue ride in Bayou Pierre Part. This photograph was taken in 1948. The house on the other side of the bayou belonged to Joseph Landry and Cedilla Chedotal Landry.

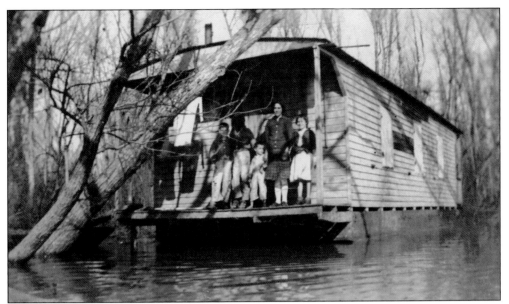

Bernie Grandin and his wife, Angella Domingue Grandin, lived on a camp boat (pictured here in the mid-1930s) with their four children, Noeline, Horace, Leroy, and Beulah. Bernie would move the boat to where he could find work as a logger. (Courtesy of Ruby Metrejean and Beulah Grandin.)

The Pipsair family gathers to take a photograph in the early 1930s. They are, from left to right, (first row) Wildy Daigle, Nollie Pipsair, Melanie Leonard Pipsair, and Frank Pipsair; (second row) Maude Daigle Perera, Hubert Daigle Sr., Justilia Pipsair Daigle, Earline Daigle LeBlanc, Molly Pipsair Gros, and Margie Pipsair Richard. (Courtesy of Georgiana Cavalier Cox.)

Elvidge Blanchard is enjoying the outdoors with two of his great-grandchildren. The children enjoyed the swing as much as he did. Elvidge was born September 6, 1854, and lived 100 years, passing away on October 18, 1954. (Courtesy of Duffy and Myrtle Matherne Landry.)

This 1950s postcard features, from left to right, LeRoy, Percy, Lloyd, and Vernisse Matherne Theriot on the porch of their family home. (Courtesy of Duffy and Myrtle Matherne Landry.)

Beaugard "Polk" Vaughn is pictured here with his wife, Laura Richard Vaughn. Polk ran the ferry that crossed Belle River, and they lived next to the ferry on the bayou. In the early 1900s, Polk had a dance hall in the back of his house. Polk and Laura had three children and raised two others. (Courtesy of Grace Vaughn Dupre.)

Pictured here in 1929 are Dorothy Vaughn Chiasson (left), Elda "Dod" Vaughn St. Germain, and Wilbert "Bill" Vaughn. They were the children of Beaugard and Laura Richard Vaughn. (Courtesy of Grace Vaughn Dupre.)

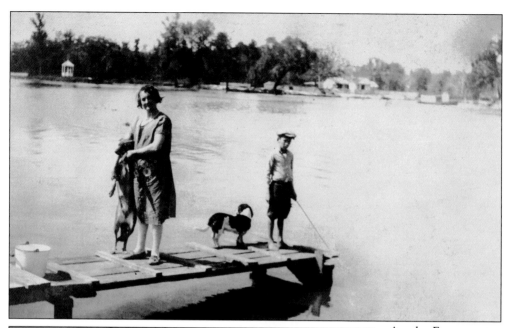

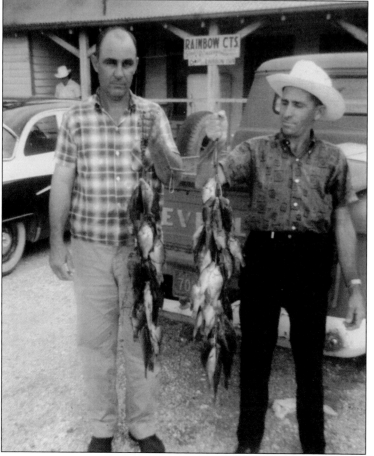

Ameley Fournerette fishes as his companion holds the dog in early 1920. Pierre Part Bay was always a good place to fish. Ameley lived on North Bay Road next to the Country Club with his parents. (Courtesy of Levie Gaudet Theriot.)

This looks like a good day of fishing for these two men. People would come to Pierre Part to fish, and fish could always be caught in the surrounding bayous. These unidentified anglers are standing in front of the Rainbow Inn Courts in the late 1960s. (Courtesy of the Moise and Ann Landry Breaux family.)

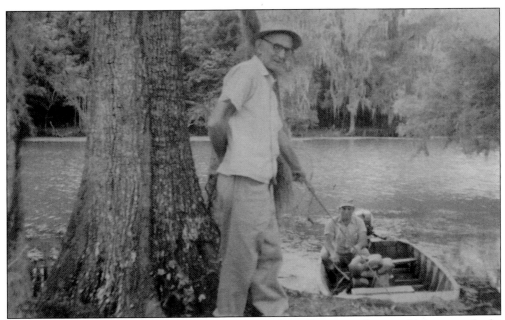

In 1850, Hardin Burnley built Bayou Natchez Sugar Cane Plantation. It was told they once had a road that connected to Pierre Part from the plantation. In the time of the silver war, Hardin held people from the soldiers. They were found on the plantation, and Hardin was put in jail and lost his plantation. Today the steel rollers can be found in the swamp. In 1943, Raymond Egle and Edna Jeanne Zeringue Egle bought the land from R.E. Kidd. Raymond brought a tractor, a bulldozer to keep the land clear, and cattle. A logging company cleared some trees, but he did not want any cypress cut. In 1920, the cypress trees were all cut, except the small ones. The Egle family still owns this land, and the Pierre Part Hunting Club leases it for hunting. Pictured here are Raymond Egle (standing) and Godfrey Cavalier at the Hardin boat ramp. Below are three of Raymond's grandchildren, Thomas Brown (left), Eva Brown Tregle, and Hugh "Brownie" Brown III, around the tractor. (Above, courtesy of Marilynn Egle Sonnier; below, courtesy of Eva Brown Tregle.)

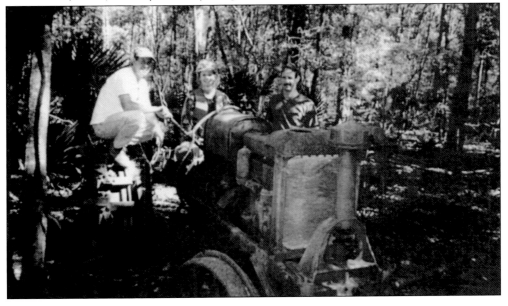

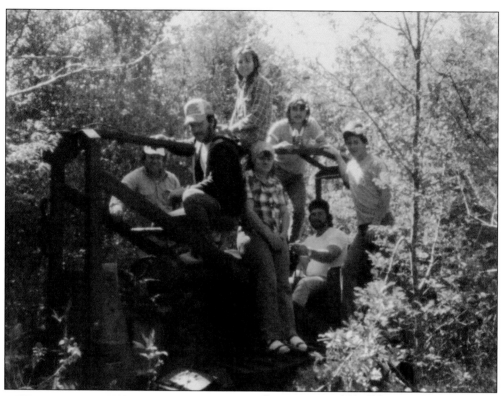

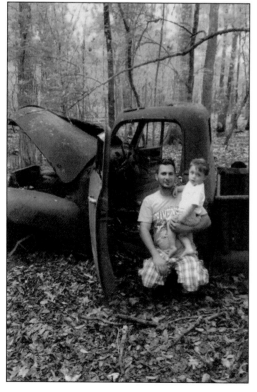

Sitting on an old bulldozer in the early 1980s are, from left to right, (first row) Carol Richard Sr., Tammy Domingue Daigle Carbo, Kevin Daigle, and Carol "Bro" Richard Jr.; (second row) Darryl Leonard, Jeannie Daigle Cavalier, and Larry Cavalier. The bulldozer was owned by the Egle family and used to clear the land for farming. (Courtesy of Joe and Marion Gaudet Daigle.)

In 2012, Seth Cavalier and his son Brant are by the old truck in the woods of T-Godell. The truck belonged to Brant's great-great grandfather Raymond Egle. Brant is the fifth generation of the Egle family. His mother, Laci Brown Cavalier, is the granddaughter of Hugh Brown. Brant was two years old in this photograph. (Courtesy of Seth and Laci Brown Cavalier.)

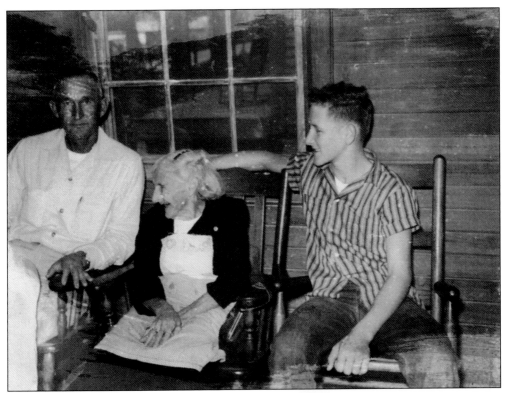

On Christmas Day 1957, Jack Dabney, Rose Lee "Taunt Lee Lee" Breaux, and Stanley Matherne rock on the front porch. Stanley loved to hear the stores Taunt Lee Lee would tell. (Courtesy of Duffy and Myrtle Matherne Landry.)

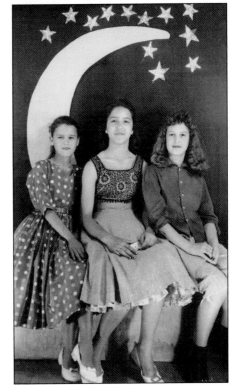

From left to right, Lucy Rivere Lang, Myrtle Matherne Landry, and Joyce Blanchard Scully are sitting on the moon. In the late 1950s, everyone had their picture taken sitting on the moon. (Courtesy of Duffy and Myrtle Matherne Landry.)

Pictured here are next-door neighbors Horace Grandin (left) and Charles Templet Sr. (right). Grandin served in World War II, and died at the age of 36. (Courtesy of Ruby Metrejean and Beulah Grandin.)

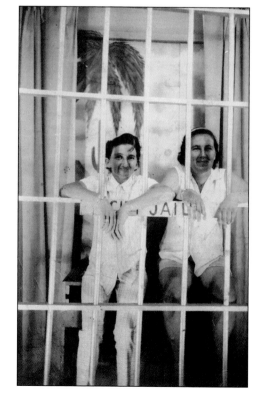

For every event in Pierre Part, a man would come to the Rainbow Inn and set his jail up to take pictures. Rita Mae Theriot Hebert (right) and Amile "T-Amile" Gros Grandin Metrejean took this photograph in 1970. (Courtesy of Melvin Jr. and Melissa Lombas Hebert.)

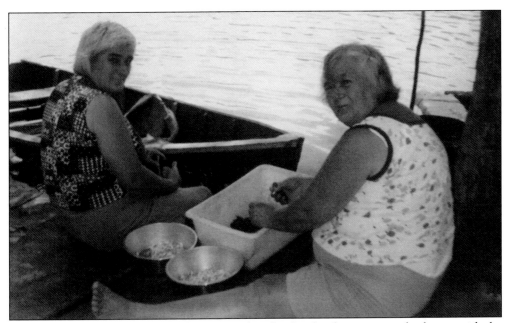

The most relaxing time can be had sitting on the wharf under the cypress and oak trees with the breeze coming from Lake Verret. Beulah Grandin (left) and her sister Noeline Grandin Metrejean are picking crawfish. Beulah still lives a simple life, much like she did growing up. (Courtesy of Ruby Metrejean and Beulah Grandin.)

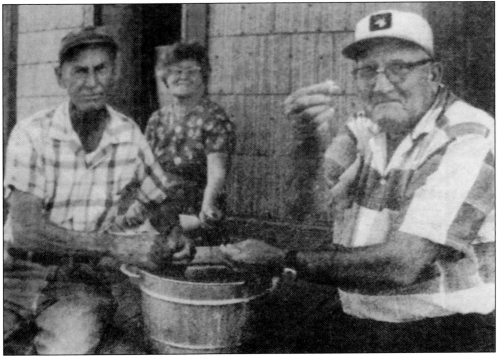

Picking crawfish in 1972 are, from left to right, Able Hebert, Lillian McCarty Alleman, and Daily Alleman. Crawfish could be cooked many ways after they were picked. (Courtesy of Kirby and Emelda Domingue Gaudet Landry and *LePenseur*.)

Sho Sho Cavalier, holding Roy Metrejean Jr., Roy Metrejean Sr. (rocking), and Virgis Metrejean (standing) visit on the porch. Sho Sho loved visiting at the house of Roy and Amile Gros Metrejean. The Metrejeans still live in this house on South Bay Road. (Courtesy of Georgiana Cavalier Cox.)

Pauline Landry always loved to cook for her family. Her kitchen was always full of friends and relatives. With fresh chickens in the yard, they would clean and cook them often. The Landrys are pictured here getting ready to eat some chicken. From left to right are Douglas Pipsair, Reno Landry, Pauline Landry, Lou Mae Landry Pipsair, Effie Landry, Linda Landry, Willy Landry, and John Pipsair Sr. (Courtesy of Effie Landry.)

Betty Hebert Hebert took this photograph of the little footbridge that went from T-Bayou to the back of St. Joseph Church. At one time, this bridge was the only way to cross without a boat; there was no road. (Courtesy of Betty Hebert.)

Mark Solar stands on the little bridge to fish. This bridge was made to get to T-Bayou, (Sub Station Road), from the graveyard in back of St. Joseph Church. Upon close inspection, the graves in the back of the church are visible. (Courtesy of Kirby and Emelda Domingue Gaudet Landry and *LePenseur*.)

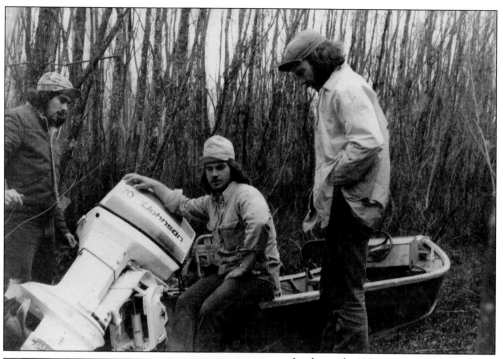

In the early 1980s, one could always find these men in each other's company. They worked, hunted, and fished together. They were going hunting in Grand Lake when, before they knew it, they were dry docked on a sand bar. From left to right are John Brouiellette, Larry Cavalie, and Darryl Leonard. (Courtesy of Larry and Geneve Daigle Cavalier.)

Raymond Sedotal was a man of many talents, pictured here carving ducks at the age of 79. As a young man he was a lumberjack, commercial fisherman, carpenter, boat builder, and bus driver. He retired at 62 and started carving ducks. (Courtesy of Joseph "Joe" and Cheryl Campo Sedotal.)

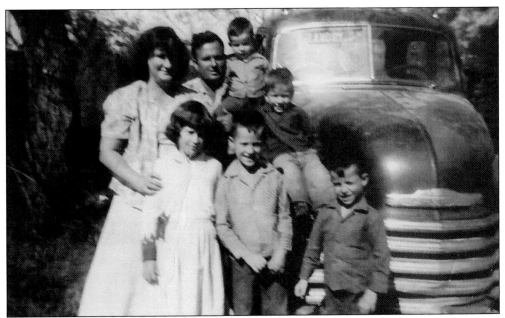

Armand Cavalier Sr. and his family stand next to their truck in the late 1950s. From left to right are (first row) Judy Cavalier Breaux, Douglas Cavalier, and Donald Cavalier; (second row) their mother Angelle Hebert Cavalier, Armand Sr. holding Michael "Mike" Cavalier, and Larry Cavalier on the truck. (Courtesy of Angelle Hebert Cavalier.)

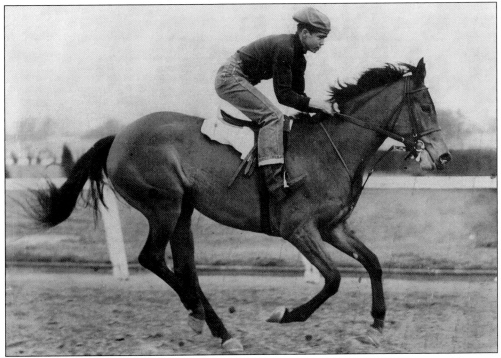

Herbert Cavalier, the son of John and Zelmire Cavalier, is pictured here in 1954. He started his career as a professional jockey at New Orleans Fairgrounds. On May 17, 1954, at Sportsman Park in Cicero, Illinois, he took a spill in a race and never walked again. (Courtesy of Loretta Ramagos Cavalier.)

Pictured here at Georgiana Cavalier Cox's 11th birthday party, are, from left to right, (first row) Gerald Ackman, Rose Ella Gaudet Landry, Hubert Daigle Jr., Georgiana, Ann Marie Perera Guillot, Donald Perera, Audrey St. Germain Guillot, Rita Mae Pipsair Matherne, and Helen Gaudet Dugas; (second row) Claude and Noeline Pipsair Cavalier, Delta Blanchard Daigle, Hubert Daigle Sr., Relma Gaudet Dugas, and Deanna Perera Glynn Aucoin. (Courtesy of Georgiana Cavalier Cox.)

Faye Theriot Ruiz was born in 1951. Here, they are celebrateing her sixth birthday. She had many family and friends that attended her party. Pictured here are some of them, including Barbara Theriot Clement, Mike Daigle, Tony Daigle, Mark Giroir, Karen Gaudet St. Germain, Gail Theriot Hue, Faye, Linda Metrejean Gaudet and Perry Theriot. (Courtesy of Levie Gaudet Theriot.)

In October 2011, Pierre Part Store held a 100th anniversary event. People came from near and far to help celebrate the store's 100 years in business. They had live bands, dancing, and talent performances. Many people brought tents and cooked while they listened to the bands. At dark, the Pierre Part Store put on a fireworks display, and everyone had a wonderful time. Pictured here in front of the stage are Kenneth St. Germain (center left, at microphone) and Gerald St. Germain (center) awarding Effie Landry for serving the store for almost 60 years. (Courtesy of Effie Landry.)

The Richard Brothers were inducted into the Louisiana Hall of Fame on June 12, 2005. Lester Richard (left), Alma "Taunt Beau" Rivere Blanchard (center), and Carol Richard hold up their plaques. Alma, their aunt, was 90 years old at the time. (Courtesy of Florence Richard Hartman Landry.)

Posing on the steps are, from left to right, (first row) Dianne Matherne Landry, Earl Matherne, Stanley Matherne, and Audrey ?; (second row) Myrtle Matherne Landry, Eleanor Matherne Landry, Patsy ?, and Connie ?. (Courtesy of Duffy and Myrtle Matherne Landry.)

Among those pictured here are Joe Gaudet, Sarah Leonard Gaudet, Bradly Richard, Marion Gaudet Daigle (holding her dog), Sammy and Ann Breaux Landry, and Joe Daigle. Joe Daigle's retriever and babies are sitting on the ground (from left to right): Phillip "P.J." Richard Jr., Leonna Richard Domingue, Kevin "Crook" Daigle, and Sullivan Gaudet. (Courtesy of Joe and Marion Gaudet Daigle.)

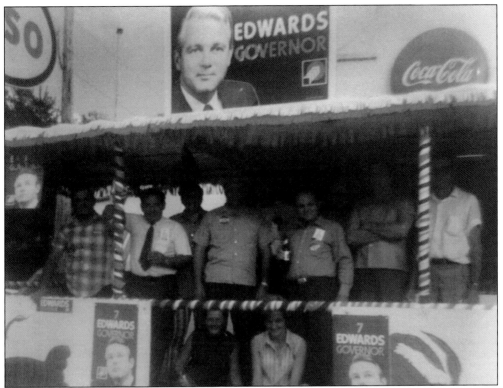

Pictured here at a rally for Edwin Edwards in 1971 at the Rainbow Inn are, from left to right, Joe Daigle, Lester Richard, Calvin Landry Sr., unidentified, Andrew Metrejean, and two unidentified men. The organizers reused the float that they made for the Crawfish Jubilee. (Courtesy of Joe and Marion Gaudet Daigle.)

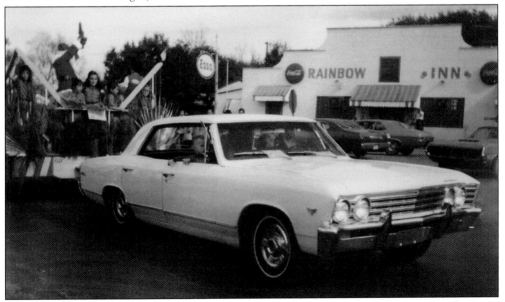

Pictured here in the mid-1960s is the first annual Pierre Part–Belle River Christmas Parade. Santa Claus was leading the way. (Courtesy of Nicky and Koonie Chedotal Ourso.)

The Assumption High Band was marching in the Pierre Part–Belle River Christmas Parade. People crowded the streets in front of the Rainbow Inn to watch. (Courtesy of Moise and Ann Landry Breaux.)

Pictured here is a pirogue race in Pierre Part Bay; the racers are all lined up to start. Pirogue races were held during the church fair and the Crawfish Jubilee. (Courtesy of Shoni Ponville Hebert.)

Standing in front of the church enjoying the Crawfish Jubilee Festival are, from left to right, Annette B. Matherne, Rachel Landry, Francine Blanchard Domingue, and Brenda Blanchard Hebert. They were wearing long dresses and had *garde-soleils* (sun bonnets) on. (Courtesy of Francine Blanchard Domingue.)

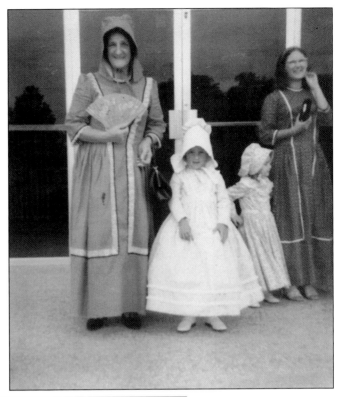

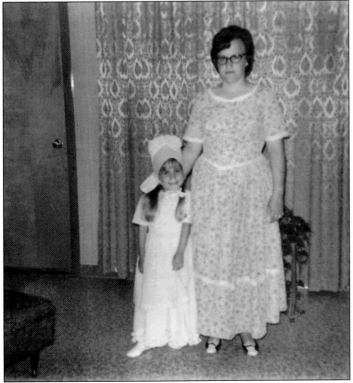

On March 5, 1970, Pierre Part held a Crawfish Jubilee. Some men grew their beards long, and women wore long dresses and bonnets. Pictured here are Geneva Breaux Gros and her daughter Monica Gros Aucoin dressed for the parade. (Courtesy of Geneva Breaux Gros.)

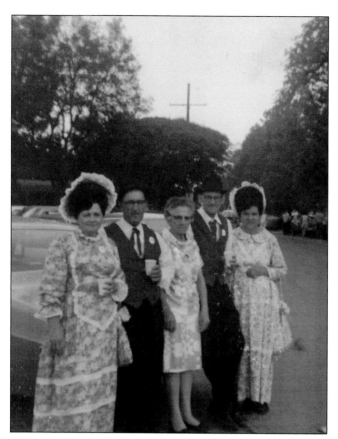

From left to right, Nelly Gauthreaux Lacoste, Wilber Lacoste, Rose Crochet, Edrick "Pete" Mason, and Annie Crochet Mason are all dressed up for the Crawfish Jubilee parade. (Courtesy of Georgiana Cavalier Cox.)

Pictured here in their front yard watching the parade are, from left to right, Emelda Landry, Virgilee Giroir Aucoin, Sterling Aucoin, Patty Aucoin Templet (back to camera), Addison Daigle (white shirt), Tessa Aucoin Mabile (in front), and Connie Guillot Daigle. (Courtesy of Wildy and Hilda Landry Templet.)

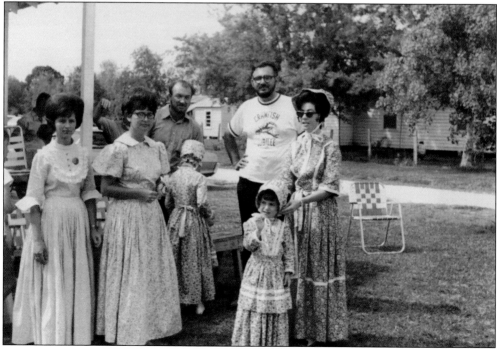

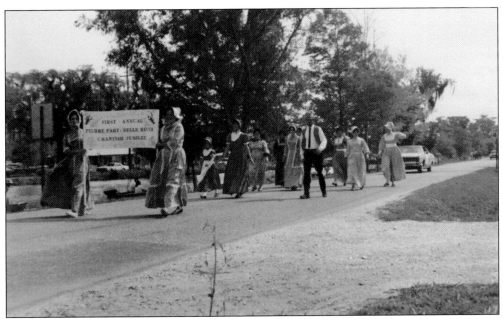

Pictured here is the first Annual Pierre Part–Belle River Crawfish Jubilee parade. The parade was one of the many attractions of the jubilee in May 1970. The jubilee committee led the parade, but many businesses had floats, bands, queens, carriages, and horseback riders. After the parade, there were contests: crawfish races, crawfish picking, greatest crawfish cook off, pirogue races, crawfish eating, and biggest crawfish. In the late afternoon was a *fais do-do*, or dance party, with plenty of good dancing music. (Courtesy of Wildy and Hilda Landry Templet.)

Pictured here is the Assumption High Marching Band, from the parish-wide high school. Band members come from Pierre Part, Paincourtville, Plattenville, Napoleonville, Labadieville, and Bayou Louis. (Courtesy of Wildy and Hilda Landry Templet.)

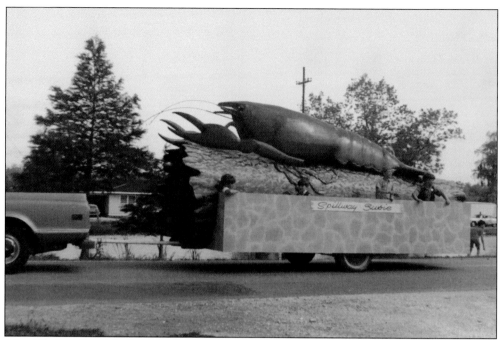

Alger "Pip" and his wife, Roberta Breaux Daigle, along with Leonard and his wife, Ruby Boudreaux Breaux, were owners of Breaux and Daigle's. Pictured here is their float "Spillway Susie." (Courtesy of Wildy and Hilda Landry Templet.)

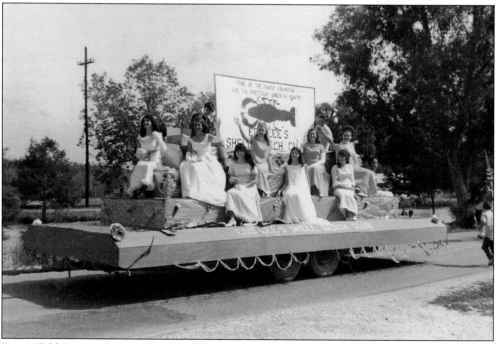

Percy "Edd Lee" and Doris Landry Delatte owned Edd Lee's Shell Beach Club and Edd Lee's Restaurant. Pictured here is Edd Lee's Shell Beach Club float. (Courtesy of Wildy and Hilda Landry Templet.)

Buddy's Drive Inn was owned by Brent "Buddy" Jr. and Georgiana Cavalier Cox. Pictured here is their float. (Courtesy of Wildy and Hilda Landry Templet.)

This float was built by many friends who loved to have a good time. They had a special guest riding with them, "Buckshin Bill." (Courtesy of Wildy and Hilda Landry Templet.)

DISCOVER THOUSANDS OF LOCAL HISTORY BOOKS FEATURING MILLIONS OF VINTAGE IMAGES

Arcadia Publishing, the leading local history publisher in the United States, is committed to making history accessible and meaningful through publishing books that celebrate and preserve the heritage of America's people and places.

Find more books like this at
www.arcadiapublishing.com

Search for your hometown history, your old stomping grounds, and even your favorite sports team.